CUT UP
THIS BOOK!

CUT UP
THIS BOOK!

Emily Hogarth

RUNNING PRESS
PHILADELPHIA • LONDON

CONTENTS

Conceived, designed, and produced by
Quarto Publishing plc
The Old Brewery
6 Blundell Street
London N7 9BH

QUAR: BPAC

Editor Lily de Gatacre
Art Editor Joanna Bettles
Art Director Caroline Guest
Designer Anna Plucinska
Design Assistant Rohit Arora
Copy Editor Sarah Hoggett
Photographers Simon Pask and Phil Wilkins
Picture Researcher Sarah Bell

Creative Director Moira Clinch
Publisher Paul Carslake

Running Press Book Publishers
2300 Chestnut Street
Philadelphia, PA 19103-4371

Visit us on the web!
www.runningpress.com

 PROJECTS 44

 TEMPLATES 92

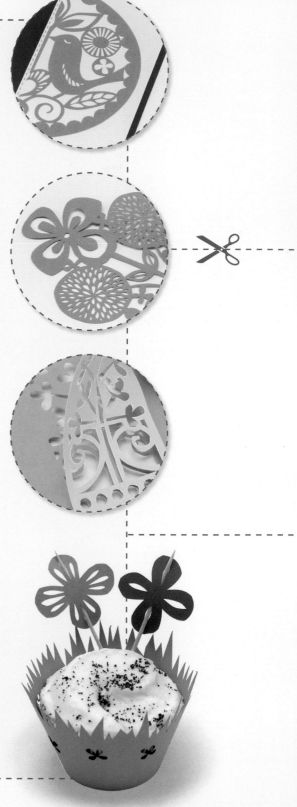

I have always loved paper and the millions of uses it has. While studying at art college I came across papercutting and instantly fell in love with the craft. I was drawn to the fact that you can create something magical out of a simple piece of paper, changing it from an everyday essential to something that can be so delicate, decorative, and treasured. Papercutting has stood the test of time, and today there are many amazing papercutting artists adding their own style and injecting new life into this craft, and it is becoming increasingly popular.

In this book I hope to introduce you to the enchanting world of papercutting. Through the variety of projects you will learn about tools and techniques, and create some lovely pieces for your family and friends. I hope that this book will become a great reference for you, to come back to time and time again for inspiration, ideas, tips, and templates to create your own amazing papercuts in the future.

Happy cutting x

Emily Hogarth

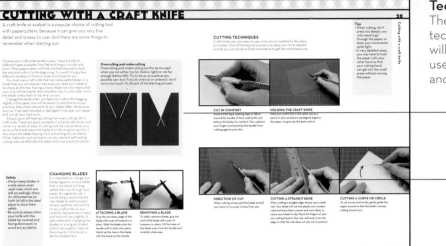

Techniques (pages 16–43)

The first section will introduce you to the key techniques needed to start papercutting. You will find out how to master your craft knife, use templates, design your own papercuts, and display your finished artwork.

Diagrams clearly illustrate important points, key skills, and explain common pitfalls.

Cutting methods are demonstrated in photographs so you can compare and check your technique.

Projects (pages 44–91)

Twenty fantastic and varied projects to follow so you can hone your skills while creating original pieces of art which you can give as gifts or use to decorate your home.

A graphic at the beginning of each project will point out the trickiest areas to cut. Take extra care around these areas.

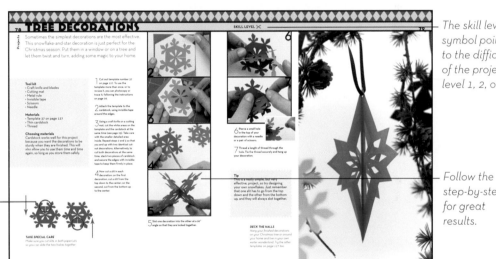

The skill level symbol points to the difficulty of the project—level 1, 2, or 3.

Follow the step-by-steps for great results.

Templates (pages 92–142)

At the back of the book you will find 50 unique templates that you can cut out from the book or photocopy to use again and again. When you see "fold out the flap," open up the pages for an extra large template.

Using a craft knife or a pair of scissors, cut along this line to cut the page straight out of the book.

Each template links to a project with similar techniques so you can follow the steps and keep on the right track.

HISTORY OF PAPERCUTTING

The art of papercutting has thrived for centuries and has taken root in lots of different cultures all across the globe.

You are likely to have been introduced to papercutting as a child with the simple task of creating snowflakes by folding a single piece of paper and snipping away at its edges and corners until, as if by magic, you unfold it and are left with a beautiful, delicate, and symmetrical design. You may not be aware, however, of the craft's long and distinguished heritage.

Paper was invented in China in the 1st century AD, and the art of papercutting soon developed, with the new material being cut into to create decorative panels for screen coverings and embroidery patterns, and to decorate windows and homes. Although in the beginning it was only available to the wealthy and royal, over time it developed into a form of folk art, being embraced by those who couldn't afford expensive tools and materials such as paints, canvases, and brushes.

Papercutting moved west through Asia and into the Middle East, and by the 16th century it had reached Europe. Along

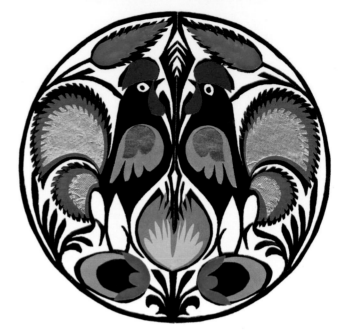

TRADITIONAL WYCINANKI
Above is an example of Polish papercutting, known as wycinanki, which often depicts roosters. The layering of paper allows more than one color to be incorporated in the design.

BOLD COLORS
Chinese papercutting often uses animals to symbolize particular years and meanings. Here, we see a papercut of a tiger in red, a popular color choice in Chinese papercutting.

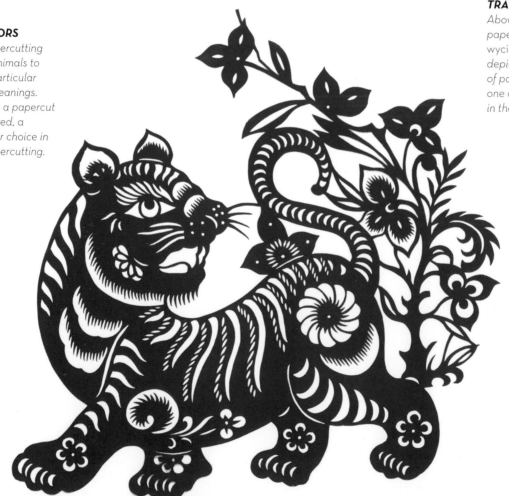

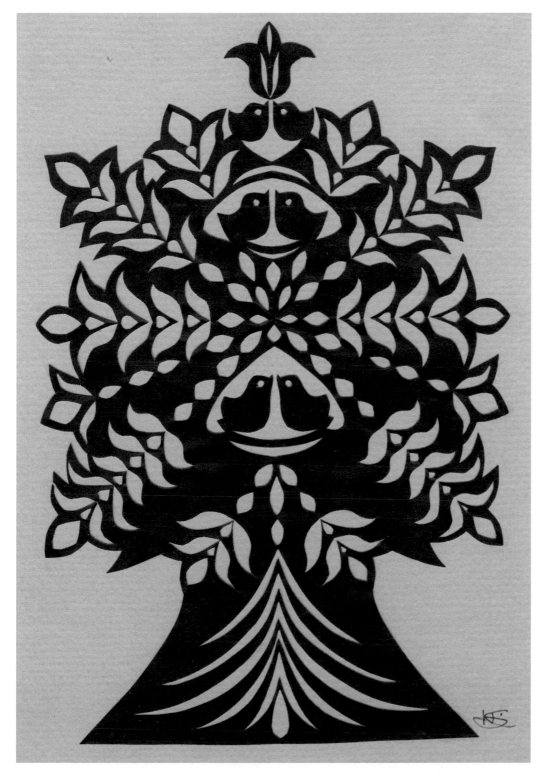

PERFECT SYMMETRY

This traditional European papercut demonstrates the popular technique of a folded design. The paper was folded in half before cutting to create a perfectly symmetrical pattern.

the way, it traveled through different countries and cultures that developed their own interpretations and styles. These interpretations have left us with a diverse and rich range of papercutting history to look back on.

In Poland, the tradition is known as *wycinanki*, which translates as "cut out." In Poland this art form was really only used by the peasants and the working classes. Papercuts were used to decorate homes, especially around festive holidays such as Easter and Christmas. The Polish papercutting style uses bright-colored papers in layers and usually depicts rural or folk scenes and motifs such as roosters. When times were tough in Poland, and Russian invaders had confiscated scissors and knives, it became common practice to use sheep shears to create these colorful decorations.

In Germany and Switzerland papercutting is called *Scherenschnitte*, which translates as "scissor cuts." This style of cutting uses small embroidery-style scissors and is often a folded design. *Scherenschnitte* is still a strong folk tradition in these countries today. The Danish storyteller Hans Christian Anderson accompanied some of his tales with simple folded and cut illustrations similar to *Scherenschnitte* designs, adding extra magic to his words.

FAMILY ALBUM (left)
Cutting silhouettes from paper became a very popular art form around the 18th century as a way of capturing the appearance of friends and family members.

CELEBRATIONS! (right)
This bright bunting is an example of papel picado, the Mexican art of papercutting. Colorful banners are created as decorations for celebrations and holidays, and cut from very thin paper to allow up to 40 sheets to be cut at once.

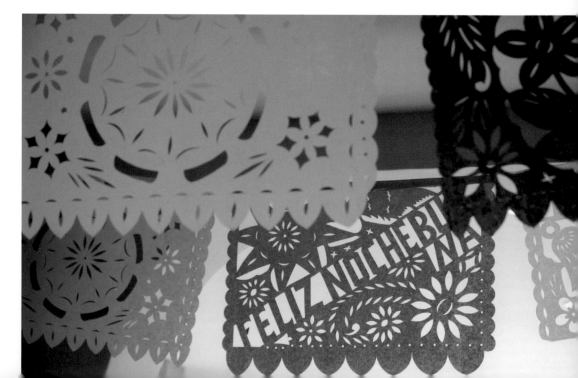

Around the 18th century, the art of silhouettes became very popular as a way of recording family portraits. Cheaper than commissioning a painted portrait, these silhouettes—or cameos, as they sometimes were called—became very fashionable, especially in England, France, and Germany. In Germany it became very popular for whole family trees, with portraits of each family member, to be cut from paper.

Papercutting has also been a common Jewish art form since the Middle Ages. Today, marriage certificates known as *ketubah* are often elaborately decorated with intricate papercut borders, creating beautiful and treasured documents.

Papercutting was brought to America by artists trying to make a living in the "new world." Immigrants from Switzerland and Germany settled in Pennsylvania in search of religious freedom and brought their art form with them. There is still a strong papercutting heritage there today.

It was also around this time that the Mexican form of papercutting known as *papel picado* started to develop. Unlike the European papercutting methods, where scissors or knives were used, Mexicans used chisels to create their decorations. Using tissue paper, as many as 40 banners can be chiseled out at a time. These Mexican banners are commonly used to decorate towns and homes around religious holidays

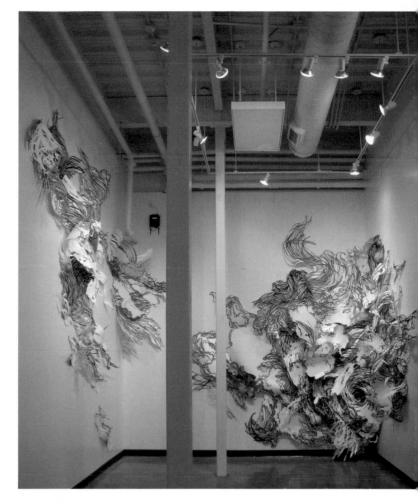

EXQUISITE DETAILS
Below is an example of papercutting artist Emma van Leest's work. Entitled "Something Lost," this piece is a beautiful example of the amount of detail that can be achieved in a papercut.

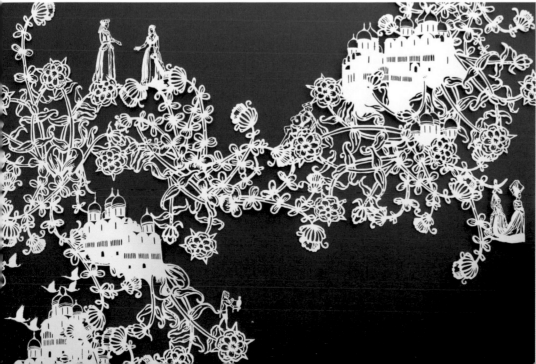

3D EXPRESSION
Mia Pearlman's papercut installation, "Havoc" shows how papercutting has progressed in the 21st century. Mia has transformed a traditionally flat art form into a 3D piece that fills a space and creates a feeling of movement even when there is none.

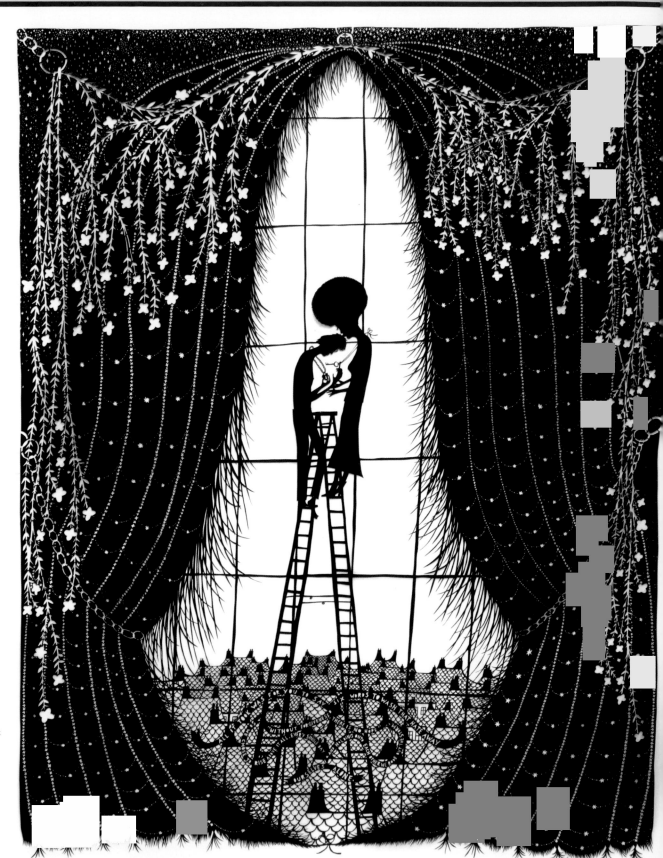

FANTASTICAL SCENES

Rob Ryan creates beautifully intricate papercut illustrations that tell stories. This piece, entitled "All It Took," is a great example of how to use positive and negative space in your designs.

such as Christmas and Easter and have been closely associated with the Day of the Dead holiday. They often depict birds, flowers, and skeletons.

Recently, papercutting has seen a revival and is becoming more popular among artists and crafters alike. Many of today's artists are influenced by its history and traditions, and it can be seen in films, design, fashion, and art all over the globe.

Artists such as Rob Ryan and Elsa Mora still use traditional cutting methods, but have developed their own illustrative styles and content, moving away from the folk scenes that were popular in the past. Their papercuts are beautiful and magical, and allow papercutting to fit comfortably within today's society. It is also great to see papercutting developing into 3D artwork. Traditionally a flat art form, modern artists such as Laura Cooperman and Mia Pearlman have pushed papercutting in new directions by creating three-dimensional installations showing just how much you can achieve with a single piece of paper.

Today, artists continue to breathe new life into this art form and push it forward, while still retaining the traditional key elements—paper, a cutting tool, and their imagination.

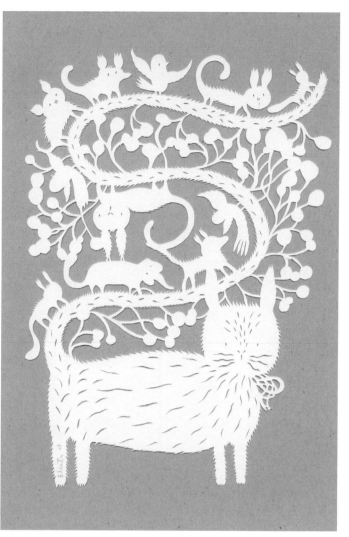

NOT JUST BLACK AND WHITE (above)
Papercutter Elsa Mora has used a light, colored paper with a colored background to add a fresh and modern twist to this art form. This piece, entitled "The Ride," is a charming example of this.

EVOLVING ART FORM
Béatrice Coron's papercut, "Rafts," is a lovely example of how modern papercutters are transforming this traditional craft and using it today.

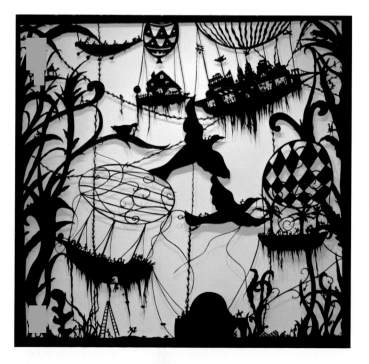

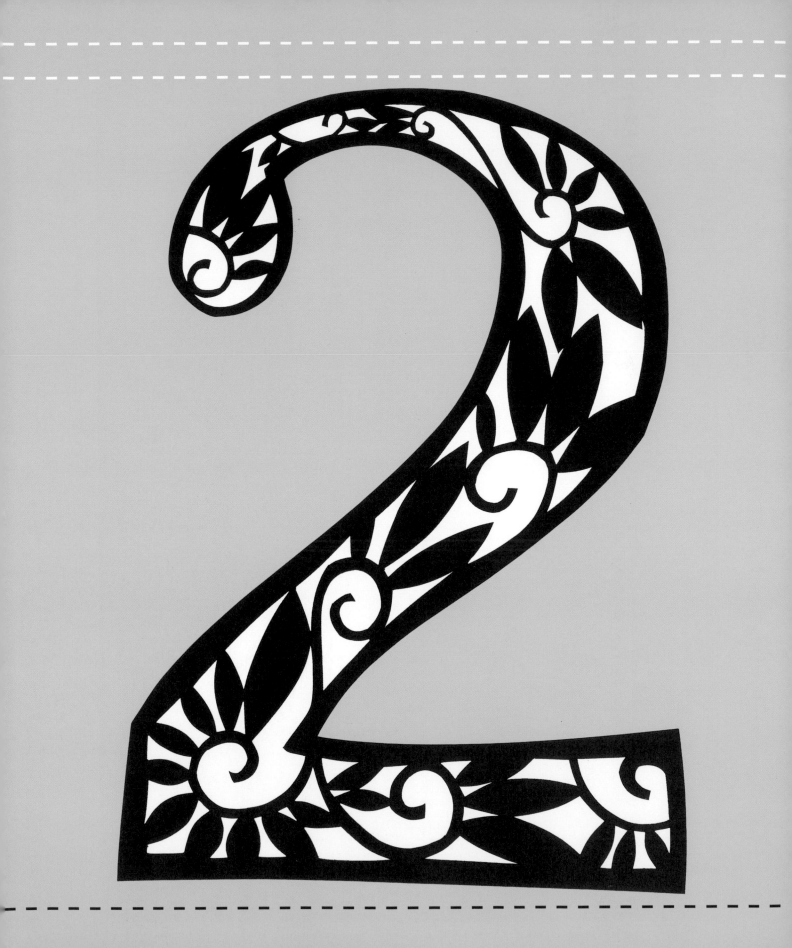

GETTING STARTED

One of the great things about papercutting is that all you really need to get started is a piece of paper and a cutting implement—although, over the years, a few extra tools have been designed to make the craft easier. This section sets out the essentials.

ESSENTIAL TOOLS

All the projects in this book have been designed to be made with as few tools as possible, but there is a basic recommended list of equipment that you should have, which is shown below. The following pages go into more detail about how to choose your paper, scissors, and craft knife, and set out some basic cutting and folding techniques.

TRACING/CARBON PAPER

Using tracing paper (1) is a great way to transfer an image to another piece of paper; carbon paper (2) is also used for this purpose. See page 26 for instructions on how to use them.

PENCIL

A pencil (3) and a pencil sharpener (4) are essential in any tool kit for drawing or modifying your designs. A medium-grade pencil such as a #2 is recommended as it gives a crisp, fine line and can still be easily erased.

ERASER

Use an eraser (5) to get rid of any unwanted pencil marks on your final piece.

ADHESIVES

There are many forms of adhesives on the market. Spray adhesives (6) are a good option for papercutting because they have less moisture in them and therefore will not warp your paper. Double-sided tape (7) is a useful alternative. This comes in rolls with two sticky sides. Peel off the backing

paper from one side and place that side of the tape on your paper, then remove the backing paper on the other side of the tape, so that you can attach it to another surface. Other forms of adhesive include glue pens (8), glue sticks (9), and (to raise paper or card slightly off the surface and give a three-dimensional effect) foam sticky pads or glue dots (10). For more information, see page 32.

LOW-TACK TAPE

You will need a good low-tack tape for securing your template to your chosen paper so it does not move as you are cutting. Invisible tape (11) and masking tape (12) are the best for this sort of work, since they can both easily be removed from the paper without ruining your papercut. I always recommend testing the tape on a scrap piece of paper first before you begin a project, so you know that you can remove it afterward.

SCISSORS

Scissors (13) are traditionally

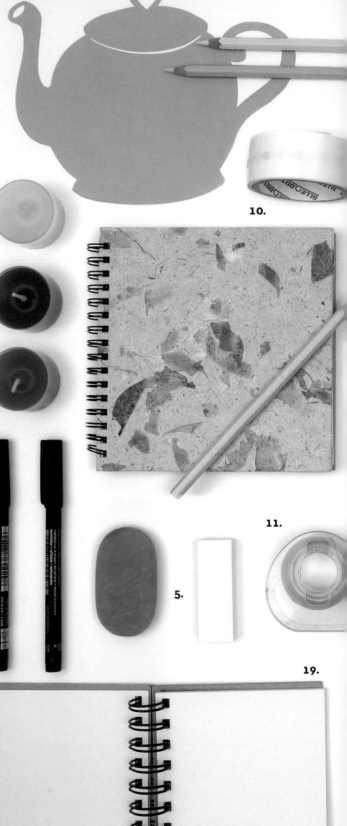

10.

11.

5.

19.

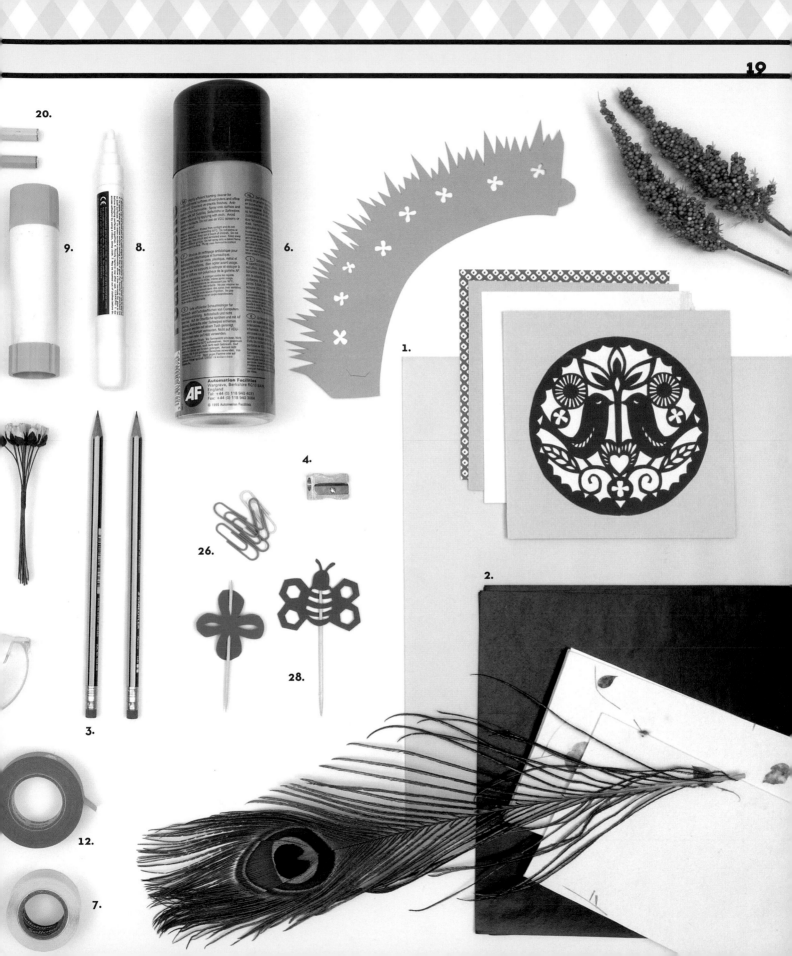

20.

9.

8.

6.

1.

4.

26.

2.

28.

3.

12.

7.

15.

18.

25.

16.

14.

17.

29.

27.

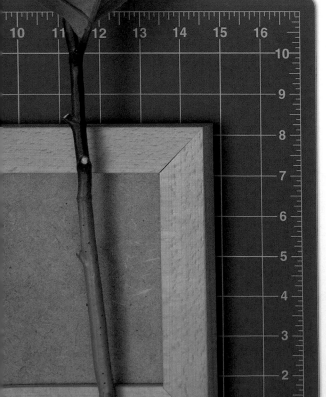

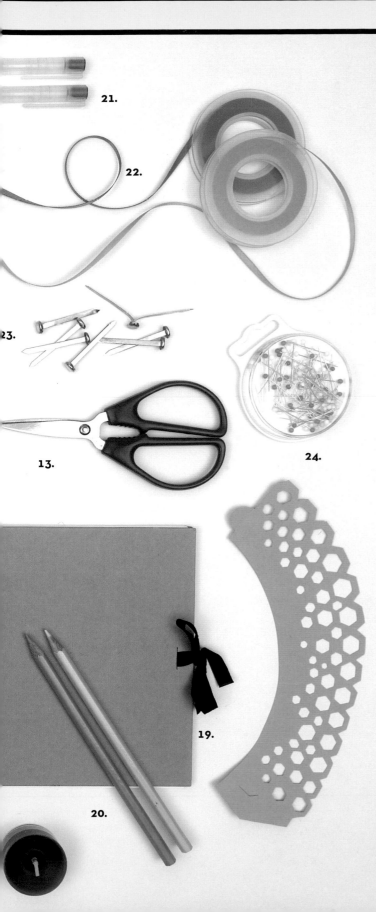

used for papercutting and there is a huge range available, some of which can be re-sharpened when the blades become dull. Be sure to buy a pair that fits comfortably in your hand, with small, sharp tips for cutting small areas. It is worth investing in a good-quality pair of scissors, but you can start with a small pair of simple embroidery scissors.

CRAFT KNIFE
A hand-held knife (14) with replaceable blades is perfect for creating accurate, neat, and intricate cuts. This tool is needed for almost all the projects in this book and can be purchased from most craft/art stores. Always have new blades to hand, since blades need to be changed regularly to make clean cuts.

METAL RULE
Always use a metal rule (15) when cutting straight edges with a craft knife, since the knife can slip and cut into plastic and wooden rules.

CUTTING MAT
A self-healing cutting mat (16) protects your table top and prevents your craft knife from slipping and you cutting yourself. Cutting mats can be purchased in different sizes and they usually have a ruled grid on them.

USEFUL EXTRAS
The following items are not essential but good to have to hand.

BONE FOLDER
Made from plastic rather than real bone, this tool helps you to create smooth, crisp creases and folds. Bone folders (17) are readily available from craft stores.

NEEDLE AND THREAD
It's always handy to have a sewing needle (18) to hand to pierce holes in your artwork, as well as thread to hang projects such as mobiles.

SKETCHBOOK
Inspiration could strike you at any time, so keep a sketchbook (19) that you can easily carry around, colored pencils (20), and fiber-tip pens (21) to ensure you never miss an opportunity to jot down a papercut idea.

RIBBON
(22) This is another useful material that's great to have in your tool kit to finish off cards and tags. Often, small scraps are all that you need, so save up remnants from gift wrappings or sewing projects.

BRASS PAPER FASTENERS
These (23) are normally used for stationery, but are a great way of adding hinged, moving parts to your projects (see pages 62–63).

PINS AND CLIPS
Household staples such as pins (24), thumbtacks (25), and paperclips (26) can come in handy for a multitude of tasks: keeping finished papercuts together, attaching inspiring images to your pinboard, or holding paper securely while glue dries. It is a good idea to keep some nearby.

Remember to read the instructions and tool kit for each project in this book before you begin. Sometimes extra equipment, such as tealights (27), toothpicks (28), or a frame (29) may be required or recommended.

Paper is the key component for papercutting: from a single piece, you can create a beautiful, delicate, and treasured artwork. Before you begin any project, therefore, it is important to think about what paper you are going to use.

Any paper can be used in papercutting, but some types are definitely better than others. High-quality, acid-free paper is always a really good option; it is the preferred choice of most papercutters because it cuts cleanly, is a good thickness, doesn't fade over time, and comes in a huge variety of colors. However, it's a good idea to play around with different types, since this allows you to find out what works best for you. Try patterned paper, watercolor paper, and even parcel paper as well as the high-quality, acid-free varieties. Each type of paper has its own qualities.

You will also find that certain papers are not as suitable for certain projects as others. For example, a papercut with fine details would be extremely difficult to cut out of a heavyweight cardstock, while a patterned paper might distract from a design that contains lots of intricate details. When designing something that will be visible from both sides, make sure that the paper is colored on both sides. Some papers crease easily (which is good for folded designs), while others will stand up to wear and tear better (which makes them a good choice for cardmaking). Recycled papers often tear easily when being cut and are therefore not an ideal choice for papercutting.

With experience you will discover which types of paper work best for you, and for the style of papercut you are creating.

Paper weights

Paper is described in different ways, but the most common description is by weight. This differs in the United States and Europe.

In the United States, paper weight is measured in pounds per ream. A ream is usually 500 sheets—so the heavier the ream, the thicker the paper. For example, printer paper is roughly 100 lb per ream, while artists' drawing paper is roughly 220 lb per ream.

In the United Kingdom and other countries outside of the United States, paper is measured in grams per square meter (gsm). Printer paper is roughly 80 gsm, while artists' drawing paper is roughly 150 gsm.

It's a good idea to try out different thicknesses (especially in the beginning), so that you know what these different weights actually feel like in your hands. So long as you know what thickness you like and need for a particular type of design, you'll know what to buy.

PAPER CHOICES
There is a huge varierty of types and weights of paper available. Be experimental and try a few different kinds to achieve various effects.

Papercuts were traditionally created with scissors, and *Scherenschnitte* cutting (see page 12) is always done with scissors, even today. Here are some of the key skills that you need to know.

(see page 12)

Tip
When buying scissors, make sure you select a pair with a grip that fits your hand comfortably.

With the exception of intercutting (page 31), all the projects in this book can be done using either a craft knife or scissors; it is entirely up to you which you use. If you do use scissors, however, there are a couple of things to remember that will make your papercutting life a lot easier.

Scissors come in different shapes and sizes and you will have to try out a few before you can decide which work best for you. You can start by practicing with craft scissors, but to achieve the more detailed and complicated designs, it is advisable to purchase some small, sharp scissors. Embroidery, decoupage, and surgical scissors all work well.

The easiest way to successfully cut with scissors is to sit down, rest your elbows on a table, and hold the piece of paper at eye height in the air. Hold your scissors in one hand; with the other hand, guide the paper into the blades. Keep the hand that is holding the scissors steady and try not to let the blades of the scissors close fully while cutting. This will give you a better line and a smoother finish, avoiding a jagged and rough edge.

BASIC SCISSOR-CUTTING TECHNIQUES
Small, detailed sections are usually the most difficult parts of a design to cut. Do them first, since your paper will stay whole for longer, which means it will be stronger and less likely to tear.

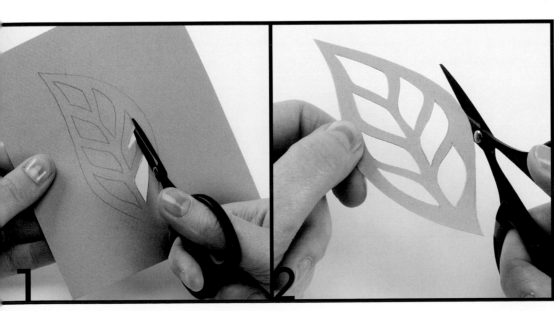

1 To cut the small, delicate sections of a design, pierce a hole in the area you are going to remove with the tip of your scissors (they must be sharp). Then make a small snip. Once you have an initial opening, ease your scissors in and carry on cutting.

2 When you have cut the inside sections of the shape, you can begin to cut around the main shape. It is important to cut the inside sections first because once the shape is cut you will find it difficult to successfully pierce the small, inside areas.

A craft knife or scalpel is a popular choice of cutting tool with papercutters, because it can give you very fine detail and is easy to use—but there are some things to remember when starting out.

Choose your craft knife handle wisely. There are lots of different types available, from flat and long to circular and short. Most papercutters will find one that they particularly like and stick with it. In the beginning, it is worth trying a few different varieties to find out what works best for you.

You must use a craft knife that has replaceable blades or a blade that you can sharpen, because you need your blade to be sharp at all times. Having a sharp blade not only means that your cuts will be cleaner and smoother, but it is also safer since the blade is less likely to slip and cut you.

Change the blade when you feel your craft knife dragging slightly in the paper; this will be easier to spot the more you practice. Also check the point of your blade often, because as soon as it has been blunted or damaged it may tear your paper and ruin all your hard work.

Always use a self-healing cutting mat when cutting with a craft knife. These are easily available in art and craft stores and come in a variety of sizes. A cutting mat not only protects your work surface and keeps the blade from blunting too quickly, it also stops the blade slipping, thus preventing any accidents. Other materials, such as board, can be used but self-healing cutting mats are definitely the safest and most practical solution.

Overcutting and undercutting

Overcutting and undercutting are the terms used when you cut either too far (below right) or not far enough (below left). Try to be as accurate as you possibly can—but if you do overcut or undercut, don't worry too much: it's all part of the learning process.

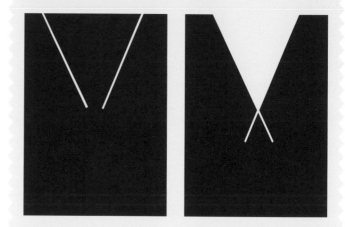

Safety
• Always keep blades in a safe place—even used ones, which are still exceedingly sharp. An old preserves jar (with its lid) is the ideal place to store them safely.
• Be sure to always store your knife with the blade tip covered and facing downward, to avoid any accidents.

CHANGING BLADES
It is important to change your blade regularly, since a blade that is not sharp will drag, rather than cut, through your paper. As a general rule, I would always recommend a new blade for each project. Always read the instructions on any craft knife you buy carefully, because each make and style will vary slightly. A safe method for changing the blades on a surgical scalpel (which was used to make all the projects in this book) is demonstrated here.

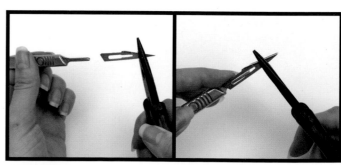

ATTACHING A BLADE
Grip the non-sharp edge of the blade with a pair of tweezers or pliers. Slide the blade onto the handle until it clicks into place. Match up the hole in the blade with the bump on the handle.

REMOVING A BLADE
To safely remove a blade, grip the end of the blade with a pair of tweezers or pliers. Lift the base of the blade away from the handle and carefully slide away.

CUTTING TECHNIQUES

Craft knives are very easy to use, once you've mastered a few basic principles. One of the keys to success is to keep your arms relaxed, so that you can produce fluid movements to get the smoothest cuts.

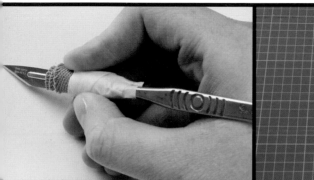

CUT IN COMFORT

Some artists tape masking tape or fabric around the handle of their craft knife, just before the blade, for comfort. This cushions your fingers and prevents the handle from rubbing against your skin.

HOLDING THE CRAFT KNIFE

Hold your craft knife in the same way as a pencil or pen—at about a 45-degree angle to the paper—to give you the best control.

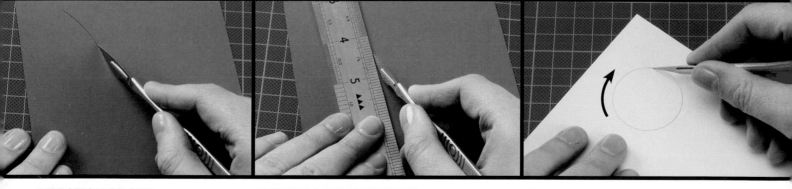

DIRECTION OF CUT

When cutting, always pull the blade toward you; never try to push it away from you.

CUTTING A STRAIGHT EDGE

When cutting a straight edge, always use a metal rule. Your blade will cut into plastic and wooden rules and leave them uneven and more likely to cause your blade to slip. Place the fingers of your non-cutting hand on the rule, well away from the edge, so that the rule does not slip out of position.

CUTTING A CURVE OR CIRCLE

To cut curves and circles, gently guide the paper around so that the blade is always cutting toward you.

TEMPLATES

If you are new to papercutting, it is a good idea to use templates, because the design has already been done for you. Once you have grasped the cutting techniques, you can start making your own designs.

This book has been designed so that you can cut the templates straight out of the pages at the back of this book (see page 7), attach them to your chosen paper, and go. Simply follow the projects step by step and you will end up with some great designs.

The solid parts of the templates should be left whole, while the white parts are the areas you should cut out to reveal your design. Once you have created your final piece, you can keep your template and draw around it again and again to create more designs on different-colored papers.

TRANSFERRING TEMPLATES

If you don't want to cut up the book, however, there are other ways of transferring a template onto a new piece of paper. Two methods are described on this page.

PHOTOCOPYING AND SCANNING

These are the most common ways of transferring a template; they also allow you to play around with the scale of the design. Photocopy your chosen template, or scan it onto your computer, re-size if desired, and print it out. Place your chosen paper on a flat surface, with the printed design on top, face up, and secure the two layers together with invisible tape to prevent them from slipping out of position while you are cutting. Then cut out the design.

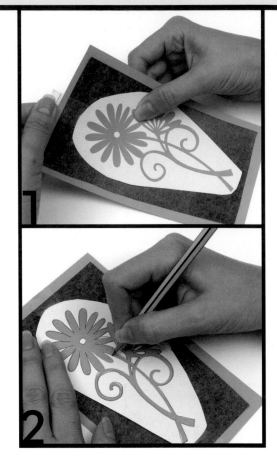

USING CARBON/GRAPHITE PAPER

You can also trace the template onto your chosen paper using carbon/graphite paper. This means when you come to do your cutting you only have to cut through one piece of paper—which can make a big difference if you're using thick cardstock. Carbon/graphite paper can be used more than once, so keep it safe after use.

1 Place your chosen paper on a flat surface, with the carbon/graphite paper (ink side down) on top. Place the photocopied or scanned template on top of the carbon paper. (If you do not have access to a photocopier or scanner, trace the image from the book onto tracing paper, then use the traced artwork as the top layer.) Secure the three layers together with a sliver of invisible tape so that they cannot slip out of position.

2 Using a sharp implement such as a pencil or pen, draw along the lines of the copied artwork. Once you have drawn all the way around the design, take the layers apart; the image will have been transferred to your chosen paper.

MODIFYING YOUR DESIGN

While you are tracing your design onto your paper, you could modify it a bit and make it your own. Layer your paper, carbon paper, and template as described to the right and secure them in place. Trace over the areas of your template that you want to keep and add any new elements you like—as long as anything you add is connected to something else it will be fine. Remember that any marks you make on your template now will translate onto your paper via the carbon. If you would like to plan your design first, draw it onto the template before you attach it to the carbon paper then trace over your new design.

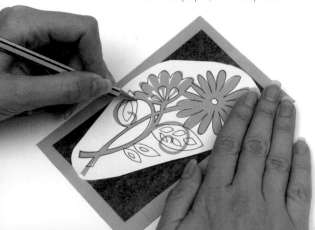

Do you remember making cut-out snowflakes as a child? Well, this is the same principle—a method of cutting that allows you to create a perfectly symmetrical design.

The first thing to think about when starting a folded design is what type of paper you are going to use: it should be a lightweight paper that creases well.

Whether you are making a single- or a multi-fold design, once you have folded your paper, do not open it out again until you have finished cutting. This not only keeps the element of surprise in your design, but it also means the paper won't slip out of position—so you'll end up with a more accurate papercut.

Finally, always be aware of where the folded edge of the pattern is: you must make sure that you don't cut all the way along this edge, otherwise your design will fall apart.

SINGLE-FOLD DESIGNS

Fold your chosen paper in half, making sure that the crease is smooth and exact. You should be able to fold it by hand, but if your paper is slightly thicker you can use a bone folder (see page 21).

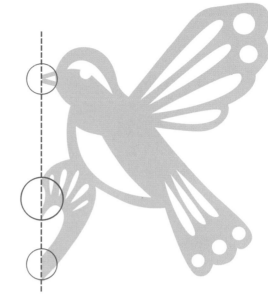

KEEP THE FOLDED EDGE INTACT
The broken line in this illustration is the folded edge: it's essential that some parts of the design remain in contact with this line, otherwise your papercut will fall apart into two halves.

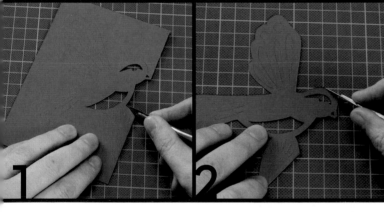

1 Start by cutting away the inner sections of your design. You may want to begin with the parts along the folded edge, since these are the important areas.

2 Then cut around the outline of the design.

3 Finally, cut away the small, tricky sections within the design.

4 Once you have finished cutting your design out, unfold it.

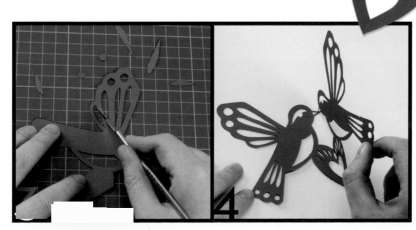

It is now that you can see exactly what your final design looks like. When you have completed your design, you may wish to flatten it to get rid of the crease. This can be done using an iron (see page 32).

MULTI-FOLD DESIGNS

Once you have mastered single-fold designs, you can move on to multi-fold designs, These are a lovely way of creating intricate patterns fairly quickly. Multi-fold designs are slightly more difficult, because you have to cut through more layers of paper at once, so it is advisable to choose a lighter paper.

TYPES OF PAPER FOLD

Here are some examples of different ways you can fold the paper, creating either two, four, or eight identical sections. (Remember that the more you fold your paper, the thicker it becomes.)

Halves *Quarters*

Diagonal quarters *Eighths (square)*

Accordion fold

Eighths (circle)

TWO FOLDS

With multi-fold designs, there is more than just one folded edge to think about. Here, there are two folded edges (indicated by the broken lines). The circles show where the design remains in contact with the folded edges; if all these sections were cut through, the design would fall apart when opened out.

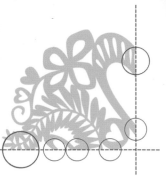

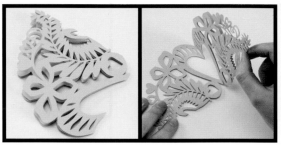

Here, the paper has been folded twice, first horizontally and then vertically, into four quarters.

As the paper is opened out after cutting, the complexity and symmetry of the design emerges.

Be very careful when opening out papercuts (especially multi-folds), because the paper can often catch on itself and tear.

SCORING AND INDENTING

Sometimes, you may want to use a heavier paper, which is too thick to fold by hand and can often leave an uneven crease. When this occurs, you can choose to either score or indent your paper to create a smoother crease. Both of the methods shown below are especially useful in cardmaking, so choose whichever method you prefer.

1 Place a metal rule along the center line where you want the fold to be, on what will be the outside surface of the paper. Then very gently slide a craft knife along the edge of the rule, remembering that you only want to cut into the paper on its surface, not all the way through.

2 Turn the paper over and gently fold it in half, with the scored edge on the outside.

3 Press the scored edge with your fingertips or a bone folder to achieve a good, sharp crease.

SCORING

This is a technique used to crease heavy paper and thin to medium cardstock. Scoring lightly cuts through the surface of your paper/card, making it easier to fold.

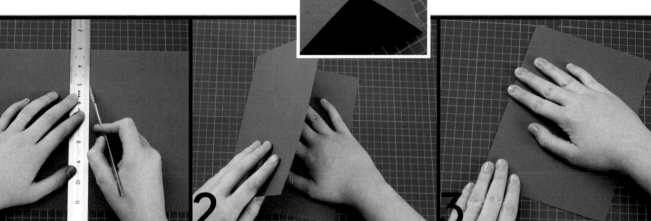

INDENTING

Indenting is used to crease heavy paper and thin to medium cardstock. It is more commonly used in the commercial industry than scoring, and uses pressure to indent a line in the card, making it easier to fold.

1 Place a metal rule along the center line where you would like the crease to be. Instead of cutting into your paper, turn your craft knife upside down and press the handle into the paper along the rule's edge, making sure you do not break the surface of the paper.

2 Fold the paper in on itself to form your fold with the indented crease on the inside.

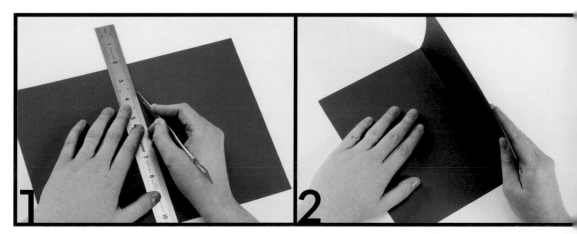

Layering and intercutting are really good ways of adding different colors and depth to your artwork. Both techniques are surprisingly easy to do—and remarkably effective.

LAYERING

Layering means exactly what you would expect it to mean: building up the artwork in stages by superimposing one layer on top of another. There is no limit to the number of layers you can have: you can simply keep adding until you are happy with the result.

One of the great advantages of designing in this way is that, if you make a mistake on one layer, you can either alter the other layers to cover up the mistake, or you can re-do just that one layer. You don't have to re-do the whole design as you would have to in a single-layered cut-out.

There are a few things to take into consideration, however. The first is to remember that you're working from the back toward the front. So if you're creating a simple landscape, for example, the first layer needs to contain the elements that you want to appear to be farthest away—the shapes of distant mountains, perhaps. Then add elements in the middle distance, such as trees. Finally, put in the foreground details—bearing in mind that each layer needs to have a solid base so that you can attach it easily and precisely on top of the previous layers. And, because of the rules of perspective, you

1 **FIRST LAYER**
Here, the trees that are intended to appear farthest away are cut out first. Note that these trees are lighter in tone than the subsequent layers.

2 **SECOND LAYER**
Then the trees in the middle distance are cut out; this layer is stuck on top of the first, partially covering some elements to enhance the feeling of recession and distance.

3 **THIRD LAYER**
To give the impression that they are closer than the previous layers, the trees in the final layer are both darker in tone and slightly larger. The three layers combined create a balanced woodland full of details and depth.

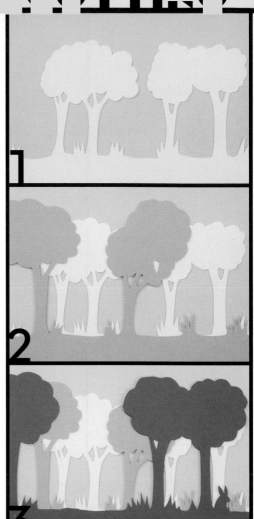

Using layers to create background colors
This is a great way to create a motif for a card, in which the background color shows through the cut-out. See the gift tag project on pages 72–73.

1 Cut out a solid shape the same size as your papercut.

2 Stick the papercut on top.

3 The layered papercut consists of two toning colors that complement each other beautifully: it would make a lovely motif for a card or gift tag.

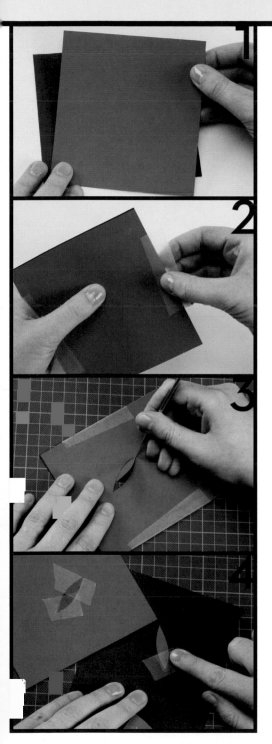

1 Choose two contrasting-colored papers, making sure that they are roughly the same weight.

2 Tape the edges of the papers securely together, so that they cannot slip out of position while you are cutting.

3 Start cutting out your design, remembering to keep hold of the pieces you are removing.

4 Once you have cut out one piece, swap the pieces over and re-attach each one to the opposite color of background paper, using invisible tape on the back of the design.

5 On the finished papercuts, the pieces fit exactly into the holes, giving the impression of a solid piece of paper that is made up of different colors, a bit like a jigsaw puzzle.

need to think about the size and tone of the layers, too: distant objects should be both smaller than those in foreground and lighter in tone.

Another thing to consider is how much space there is in the artwork. It is very easy to include too much detail on your first layer and then find that you have no empty space to add new layers. To create a simple forest of trees, for example, each layer is very sparse—but when they come together, they create a balanced woodland full of details and depth.

INTERCUTTING

Intercutting is a technique that involves cutting through two pieces of paper at the same time and then swapping the cut-out sections over. It works best when you use two contrasting-colored papers. Once you have done this, tape the cut-out piece back in place on the reverse of your design. As you gain more experience and feel comfortable with the technique, you can start adding third, fourth, and even fifth colors—there are no limits.

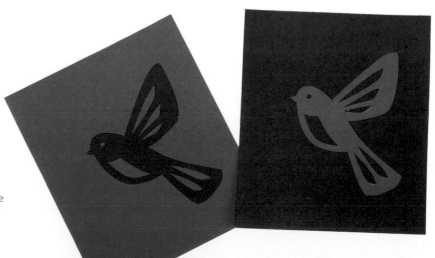

INTERCUT DESIGNS
Using the intercutting technique you can easily create matching designs in contrasting colors.

There are lots of things you can do with your papercuts—frame them as they are, attach them to a background paper, hang them around your home, or store them safely away in a folder or drawer—but we recommend you display them so that they are seen and admired.

FRAMED ARTWORK
Choosing the right way to display your artwork can turn your papercuts into professional-looking pieces of art to complement your home.

If you are going to store your artwork out of sight, always make sure it is completely flat. Depending on size, you can store your papercuts in envelopes or clear polythene pockets and display sleeves.

If you want to display your papercut artwork, you may want to consider flattening it to get rid of any creases. You can do this with an iron. Be sure to place a sheet of uncolored paper underneath and on top of your papercut and use the iron on its lowest setting. It is essential that you do not use the steam function, which will ruin your papercut.

If you want your artwork to be framed, it is sometimes a good idea to have a frame in mind before you start the project, so you know that it will fit the frame before you begin. There are so many options to choose from: simple or elaborate frames, big or small, a colored background or a mount, so be creative and think about what works best for your artwork and the style of your home.

CHOOSING THE RIGHT ADHESIVE

Often you will want to attach your papercut to another piece of paper. There are lots of different types of glues and adhesives, and they all have their advantages and disadvantages. Some raise the papercut off the surface of the background paper; others allow it to lie flat. Some are better for small, fussy areas, where the strips of paper are too small to glue individually or to apply foam pads. Think carefully which one best suits your project.

SPRAY ADHESIVE
With spray adhesive, your artwork will lie flat against the background. It is easy to get an even coverage without the risk of the adhesive seeping onto the right (visible) side of the papercut. When using spray adhesive, always read the instructions carefully and work in a well-ventilated area.

GLUE STICKS AND CRAFT WATER-BASED GLUES
Glue sticks are great because you only need a few small dots of glue on the back of your artwork to secure it in place. When using water-based and other liquid glues, do not put too much on your papercut: you don't want your artwork to get damp, since this will warp and ruin the finished design. Be careful when using water-based glues on small, cut-out details, since there

is a risk that the glue will seep over the edge and be visible on the right side.

FOAM STICKY PADS
If you would like your artwork to be slightly raised off the background paper, you can use foam sticky pads, or glue dots, used in decoupage. This is a great method to use on greetings cards and gift tags and you can cut these to any size you need. If you have to cut the pads into very tiny pieces or are using small glue dots, you may find it helpful to use a pair of tweezers to lay them in place.

DOUBLE-SIDED TAPE
Less messy than conventional glues, double-sided tape usually comes in rolls of

different widths, which you can choose and cut depending on the size and intricacy of your papercut. Similar in use to foam sticky pads, although it will not raise your design off the surface of the background paper.

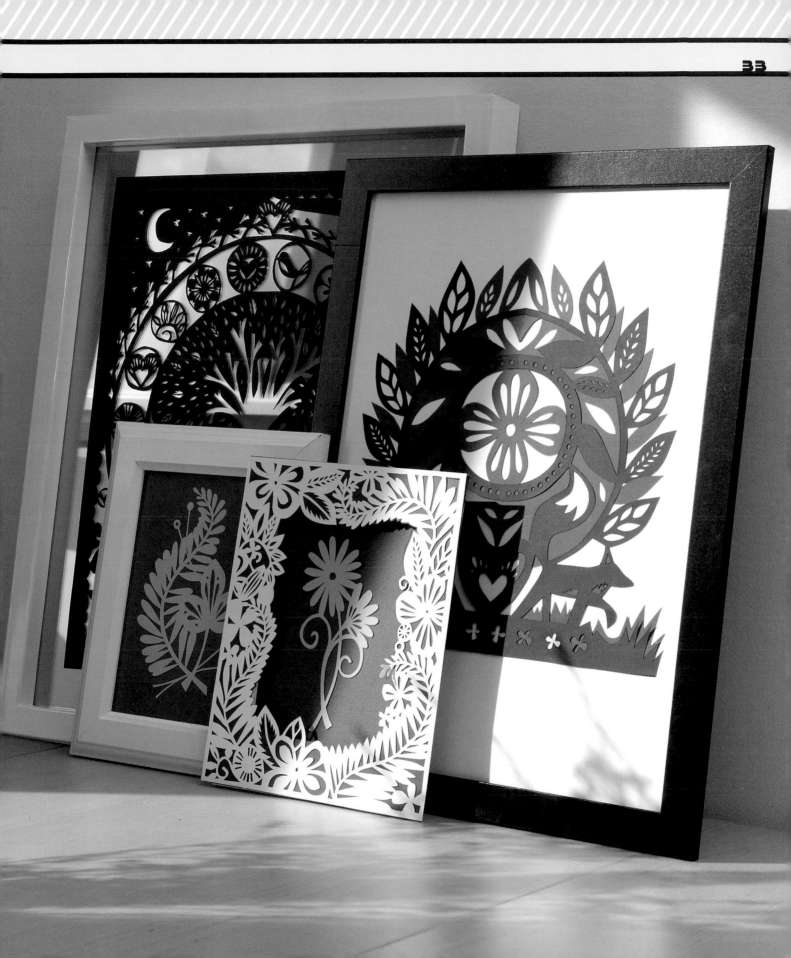

DESIGNING PAPERCUTS

You can take inspiration from everything and everywhere, but often it can be difficult to know where to begin. Here are some ideas to get you started.

The best suggestion initially is to focus your ideas on things you like. Collect images, scraps of fabric, color swatches, leaves, and flowers as well as images of other artists' work. Once you have a good selection, lay them all out and see if there is a common theme. You may find that you are repeatedly drawn to certain colors, or a particular subject, or the pattern on an object. Once you have identified what it is you like, you can translate these ideas into your own papercut artworks.

A really good method of keeping your ideas focused is to create a mood board. These are used for all kinds of creative outlets and are a great way of quickly seeing what the mood, colors, and themes of your work are going to be. They can develop and change over time, but it's a good idea to keep referring back to your mood board for inspiration throughout the design process.

For papercutting ideas, look at the work of other papercut artists that you like, both old and new. Look into colors and subjects that you want to include in your artwork. Things in nature—flowers, leaves, and stems—are great, too, and can give your artwork beautiful natural lines.

The further afield you look, the better your work will be, because you will open yourself up to a wider variety of influences and ideas. Be imaginative and don't worry about what other people think. Your inspiration should be very personal to you and should reflect what you love and what makes you smile!

Tip
When you're out and about, it isn't always practical to carry a sketchbook with you—but it's easy to take a quick reference photo on your camera or cell phone, which you can then stick into your sketchbook or attach to your mood board. Color combinations in store windows, graffiti on the side of a building, leaves seen against a bright blue sky in your local park, the shapes of everyday household objects—anything can spark off a creative idea.

COLLECTING INFLUENCES
Find the colors, patterns, shapes, artists, and themes that inspire you and keep them to hand as you develop your design ideas.

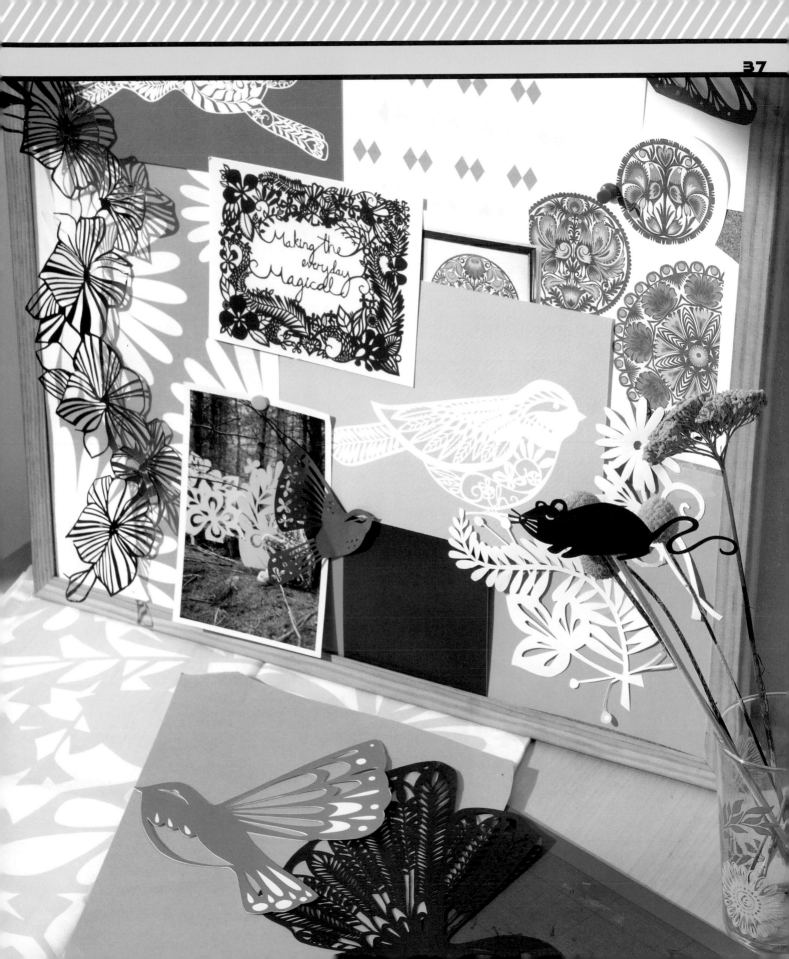

Making the everyday Magical

Once you've mastered the basics of papercutting using the templates in this book, you'll be ready to have a go at coming up with your own designs. Use your imagination: you can create anything!

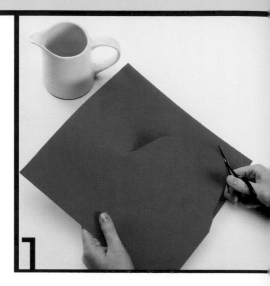

The more time you spend on planning and designing your artwork, the happier you will be with your final piece. You will also start to develop your own style: this takes time, but the more you do the more you will be able to push yourself.

A good way to start when not following a template is to try to cut out a design without drawing it first. Practice by cutting out a household object, a silhouette of someone, or a simple flower: your scissors or craft knife become your pencil. This way of cutting means you will always produce something different; no two pieces will be the same. The end result may be more simplified than something that you had drawn first, but it can give you a really lovely, naive look. The technique does take practice and you may find that your first few attempts don't look like much, but it is a great way to loosen your style. It also teaches you a lot about scale, perspective, line, and shape and makes you really look at what you are cutting. The images to the right show the process of cutting out a freehand design with scissors, focusing on the main outline to begin with, and then adding any detail.

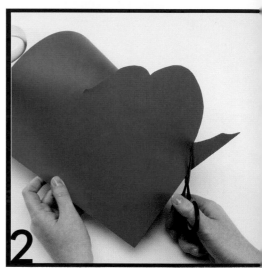

DEVELOPING A STYLE

Why not create a few freehand papercuts around a central theme and begin to develop your own personal style. You can experiment with scissors, a craft knife, different paper weights, even introducing folded designs.

1 Find a simple subject to use as
inspiration for the papercut.
Place the subject within easy view
and begin cutting. Always start with
the outline. Think of the scissors as
a pencil; you are starting to "draw"
the jug as an outline.

2 Keep snipping and comparing
the cut-out shape with
the subject.

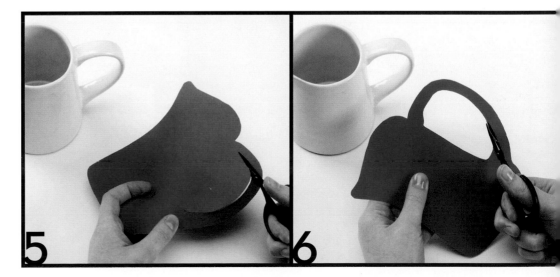

**PRACTICE MAKES
PERFECT**
*The more you
practice papercutting,
the more confident
you will feel and the
easier you will find it.*

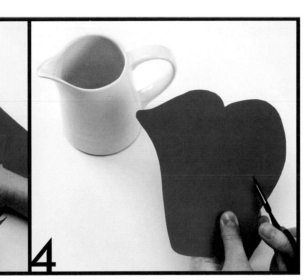
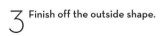

3 Finish off the outside shape.

4 Pierce inside and start to cut
out the handle.

5 Finish off the handle to
complete the basic shape.

6 Neaten the inside and outside
lines of the cutout, so the
edges are sharp and graphic.

When designing your own papercuts, you must come to terms with the concept of positive and negative elements, since this is the backbone to all papercutting.

All papercuts are made up of one piece of paper cut into two—a positive element and a negative element. The paper that we remove from a solid sheet is the positive element; the space left behind in the paper is the negative space.

When you are creating a positive design, you remove any paper that is not part of your final image. When you are creating a negative design, it's what you cut away that is your design. When you combine both positive and negative element in your designs, you can create some beautiful and very clever effects.

You can also create a positive and negative design by cutting out two colors simultaneously, keeping all the pieces you cut out, and carefully putting them back together, so that you have two papercuts that are the opposite of each other (see Intercutting, page 31).

If you are creating a more detailed design and you want to keep both the positive and negative image, you will have to be very careful to keep all the small pieces you remove from the design safe and unbroken until you need them again. Once you have completed your cut-out design, carefully position the small pieces that you have removed from the positive shape into the negative space that has been left behind in the paper. As the pieces that have been removed are separate and not connected, you will have to stick them down to a backing paper to keep them in place. This is demonstrated with the blue feather below.

Negative

Positive

BOLD DESIGNS

As well as the more intricate designs, you can create some really great positive/negative designs by cutting a bold, solid, and relatively simple shape out of your paper.

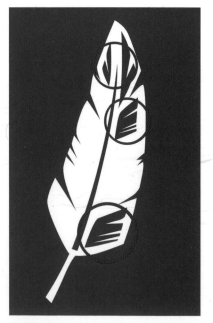

Negative

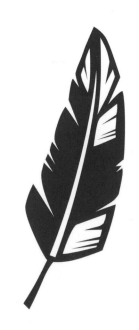

Positive

POSITIVE SHAPE, NEGATIVE SPACE

The blue feather that has been cut out (left) is the positive element. Once you have cut this design out you will be left with the small, loose details from the feather and a feather-shaped hole in the paper. To create your negative design (far left), stick the negative feather onto some backing paper and then stick the small pieces back into position on the backing paper in this space. Here, the areas that are circled in red are the small details that have been cut out of the positive design and restuck to create the completed negative design.

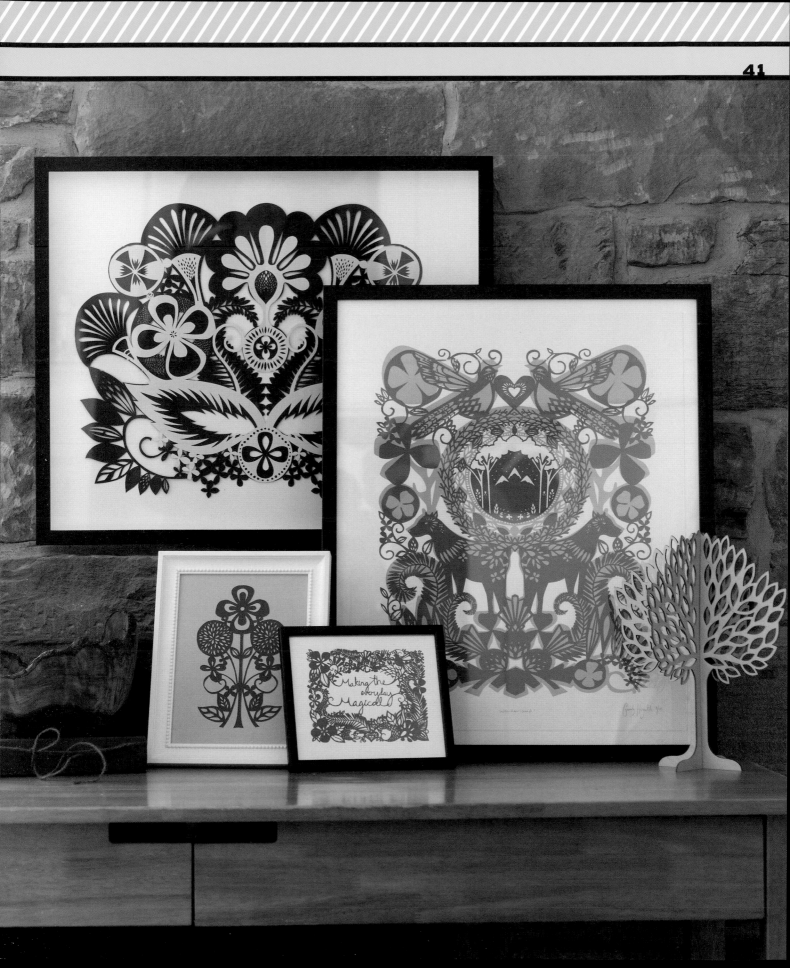

Designing Papercuts

The design that you draw on the back of your paper will be reversed when the papercut is complete, so you need to "think backward" in order to draw something that will appear the right way around.

When you design your own papercuts, your final design will be the reverse of what you draw on your paper. This is because you always draw on the back, so as not to mark the front of your artwork. Once you have completed your papercut you then get to turn it over and see what the final design looks like. Sometimes it can look quite different, while at other times it looks exactly as you thought it would.

If you want to know exactly what your design will look like before you flip it over, use a template. Rather than transferring the template exactly, flip it the other way around so that when you trace it onto the back of your paper, the image is reversed. That way, when you cut it out you will have an image that is the same direction as the original template.

CHANGE OF DIRECTION

When this design was drawn onto the back of the paper (left), the biggest flower was in the top left corner. When the design is cut out (right) and the paper turned over to the right side, the biggest flower is in the top right corner. Changes of direction such as this can have a dramatic effect on the mood of an artwork.

LETTERS AND NUMBERS

Thinking backward is really important when you want to include letters and numbers in your designs, because you have to write them backward on your paper. This takes a bit of getting used to, but the more you practice the easier it gets.

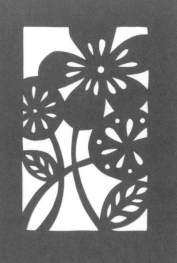

Tips
- When writing backward, remember to always check your spelling before you start!
- It is important to consider how you space your letters. You do not want the letters to be too close together because this will make them very difficult to cut, but if you space them too wide the words will not be easily read. There is no firm rule though, so play around with your lettering: printed, cursive, small, large, capital, or lower case.

WRITING BACKWARD

As you write, try not to focus on the whole word, but rather think about the shape that each individual letter makes and how this would be reversed.

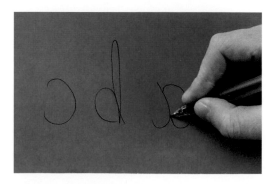

When starting a design with text or numbers, plan what you want to include and write it out on a separate piece of paper. Once you have done this, write it out again—this time backward. Rather than thinking about what you are spelling, look at each individual letter or number and what comes next. When writing backward you will find that it is easier to go from the right of your page to the left.

Once you have written out your text backward, you can check it makes sense by placing it next to a mirror. When you look in the mirror, your work should look normal. Use your backward text as your reference and copy it into your design.

Another thing to consider when using text and numbers in your artwork is the enclosed spaces within some letters. If your design is going to be a positive design, then this isn't an issue; when you are creating a negative design, however, you will have to either include the centers of the letters afterward or not at all. You will notice that a lot of artists who use text in their work often leave out the centers of their letters. It can add a lovely papercut quality to your work and is worth trying out.

CHECK YOUR WORK
Use a mirror to check how your backward letters or numbers will look once they are cut out and flipped.

Positive *Negative*

ENCLOSED SPACES
In the negative design here, the enclosed spaces in the letters will either have to be left out or carefully glued back in place, but they remain in the positive design.

ALPHABET GUIDE
You can use this alphabet as a reference when writing backward because it can be easy to get the letters mixed up. If you want to use it as a template, photocopy or trace it from the book and then use carbon paper to transfer the letters you need for your design (see page 26).

PROJECTS

This is a great project that will allow you to send your friends and family a papercut of their very own. What better way to say "happy birthday" or "thank you," or just send someone a friendly note? The border strengthens the area that has been cut, creating a sturdier finished card.

Tool kit
- Craft knife and blades
- Cutting mat
- Metal rule
- Invisible tape
- Pencil
- Bone folder
- Double-sided tape

Materials
- Template 1 on page 95
- Thin cardstock
- Paper in contrasting color

Choosing materials
You can make this card as big or as small as you wish: a 6- x 4-in. (150- x 105-mm) card will fit into a regular-sized envelope. The design should stand up when it is finished, so use a thin cardstock rather than paper. You can use a contrasting color or pattern for the insert page behind the aperture.

1 Cut out template number 1 on page 95. To use the template more than once, or to re-size it, you can photocopy or trace it, following the instructions on page 26.

2 Cut a piece of thin cardstock the same height but twice the width of your template. This is double the width of the final card: you create the card by folding the cardstock in half after cutting the design. If you would like your design to be a stand-alone piece of art, cut the cardstock to the same size as the template.

3 Using invisible tape, tape the template to the right-hand side of the cardstock, as illustrated.

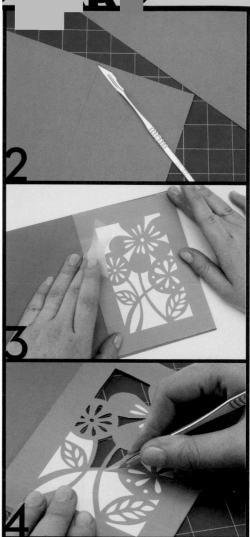

4 Using a craft knife on a cutting mat, cut out the white areas of the template and your card at the same time (see page 25). Areas that will be more tricky or delicate to cut are highlighted in the thumbnail (left). These areas connect the design to the border and are therefore more delicate, so take your time over them.

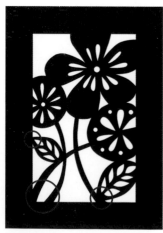

TAKE SPECIAL CARE
Circled in red are the trickiest areas to cut. These thin areas connect the cut-out design to the main body of the card.

5 Mark the top and bottom of the center of the card lightly in pencil. Align a metal rule with the pencil marks, then run a bone folder or craft knife along the edge of the rule to lightly score the cardstock; but take care not to cut right through the card (see page 29). Fold the card along the score line, then run your finger or the rounded end of the bone folder along the fold to create a sharp crease.

6 Next, make an insert for your card, using a different color of paper to create a contrast. Cut a piece of paper just smaller than the card. Fold the paper in half and check that it fits neatly inside the card. (Trim a sliver off the leading edge if necessary.)

PLAYING WITH COLOR

Why not experiment with different color combinations to create a card that really suits its recipient.

7 Cut a length of double-sided tape and apply it to the back of the insert, along the fold. Peel off the backing from the double-sided tape, then stick the insert into the card, carefully aligning the fold on the insert with the fold in the card.

FLOWER CARD

The finished card is now ready for you to write your message and send it to your recipient.

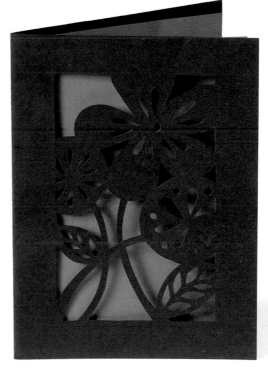

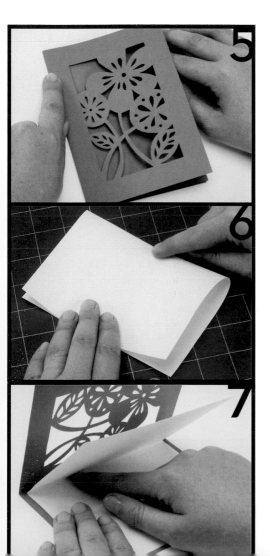

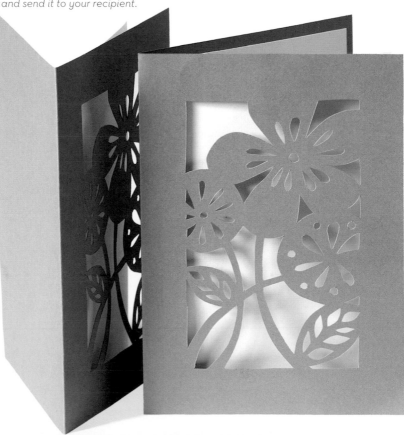

The inspiration for this card came from my grandmother's country cottage and the summers I spent there. The accordion fold adds depth to the card, creating a three-dimensional scene. When designing your own accordion folds, remember to tier the levels and to leave the back page pretty much intact, so that you have room to write a message or greeting there.

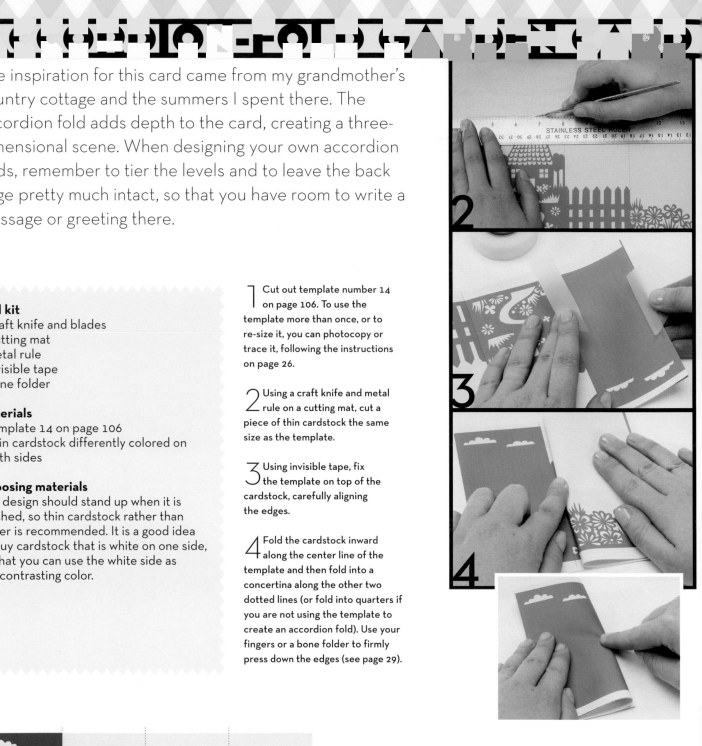

Tool kit
- Craft knife and blades
- Cutting mat
- Metal rule
- Invisible tape
- Bone folder

Materials
- Template 14 on page 106
- Thin cardstock differently colored on both sides

Choosing materials
The design should stand up when it is finished, so thin cardstock rather than paper is recommended. It is a good idea to buy cardstock that is white on one side, so that you can use the white side as the contrasting color.

1 Cut out template number 14 on page 106. To use the template more than once, or to re-size it, you can photocopy or trace it, following the instructions on page 26.

2 Using a craft knife and metal rule on a cutting mat, cut a piece of thin cardstock the same size as the template.

3 Using invisible tape, fix the template on top of the cardstock, carefully aligning the edges.

4 Fold the cardstock inward along the center line of the template and then fold into a concertina along the other two dotted lines (or fold into quarters if you are not using the template to create an accordion fold). Use your fingers or a bone folder to firmly press down the edges (see page 29).

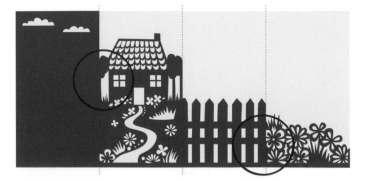

TAKE SPECIAL CARE
Circled in red are the trickiest areas to cut. These areas will be folded so avoid cutting over the folded line.

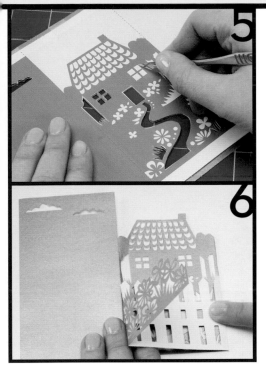

5 Open out the cardstock. Using a craft knife on a cutting mat, cut out the white areas of the template and your cardstock at the same time (see page 25). Pay particular attention when cutting near the folds because these areas will be under more stress and are more likely to tear.

6 Remove the template and fold the paper back into its accordion folds; this should be easy to do because you created the score lines when you folded the paper in step 4.

7 Stand the card up so you can see it in its full glory. Write your message on the back page behind the cottage, so that you can't see it from the front. Alternatively, write your message on the very back, so that it isn't visible from the front of the card at all.

ON DISPLAY
When displayed, your accordion-fold card will create a beautiful, layered three-dimensional scene.

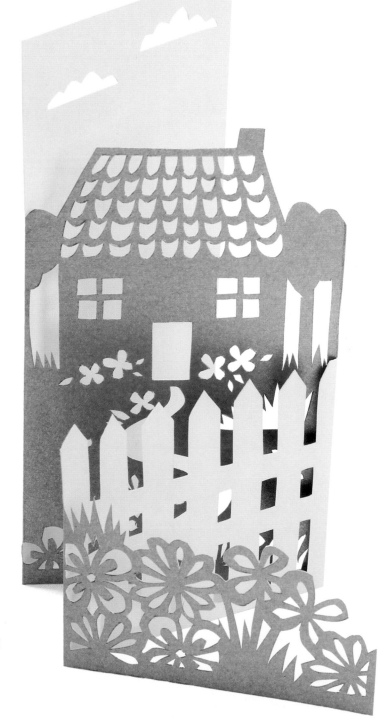

FOLK-ART GATE-FOLD CARD

Inspired by traditional folk-art papercutting patterns, this card opens out from the center and is a great idea for an invitation to a dinner party or as a menu holder. Hand write or print the party details and attach them to the inside of the card with double-sided tape or a glue stick.

Tool kit
- Craft knife and blades
- Cutting mat
- Metal rule
- Bone folder
- Invisible tape
- Spray adhesive
- Glue stick (optional)

Materials
- Template 3 on page 97
- Thin cardstock
- Paper in contrasting color for insert
- Thin ribbon (optional)

Choosing materials
The design should stand up when it is finished, so rather than paper, it is best to use a thin cardstock—not too thick, because you have to fold it in sections. You can use a contrasting color or pattern for the insert.

1 Cut out template number 3 on page 97, which is in two parts. To use the templates more than once, or to re-size them, you can photocopy or trace them, following the instructions on page 26.

2 Cut a piece of thin cardstock the same height as one of the templates, but six times the width.

3 Using a bone folder and a metal rule (see page 29), score and then fold the cardstock in thirds along the dotted lines B and C (see Paper Folds, opposite). Score and then fold each of the two end panels in half again along lines A and D. It is best to do this before you cut out the pattern, so the card will fold into place more readily at the end.

4 Unfold the card and attach the templates to the panels on either side of the wide center panel, between lines A and B, and C and D, using invisible tape, and making sure that the swans face away from each other, facing outward.

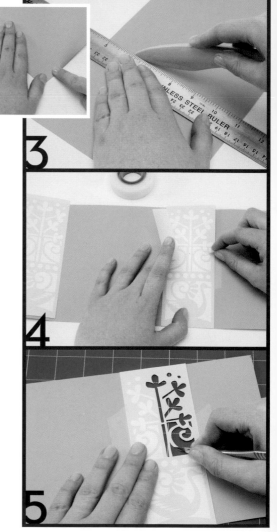

TAKE SPECIAL CARE
Circled in red are the trickiest areas to cut. The edges of this design will be folded when finished, so be careful not to cut over the folded line.

5 Using a craft knife on a cutting mat, cut out the white areas on the templates and the card at the same time (see page 25). Take particular care when cutting along the edges of the design, since these will become the folded edges of the card, connecting the design to the main body of the card, and are therefore more delicate. Remove the templates.

6 Next, measure the end flap of the card and cut two pieces of a different color of paper to these measurements for the inserts (inset).

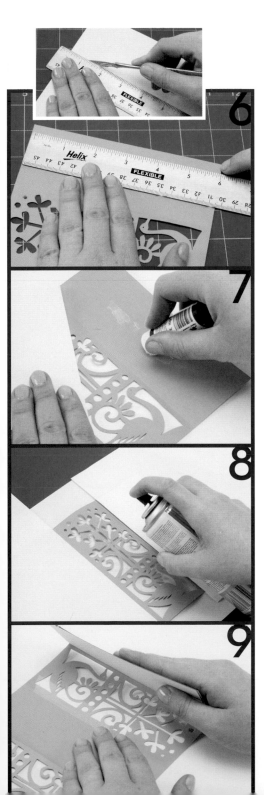

FOR EVERY OCCASION

Create an unusual greetings card or tie the color scheme and design to your party plans and make some lovely, personalized invitations or menu holders.

7 Using either spray adhesive or a glue stick, attach the inserts to the end panels of the card.

8 Spray the backs of the two cut-out panels with adhesive. This is a little tricky, because you don't want to get the glue anywhere else, so make sure you mask off all other areas with scrap paper beforehand.

9 Fold the end panels with the inserts in on themselves so that they cover the backs of the papercut panels. This is made easier because you scored the edges earlier with the bone folder. Press down firmly to secure them in place.

10 Then fold the end panels inward again until they meet in the middle. If you wish, for a neat finishing touch, tie some ribbon around the center of the card to hold it closed.

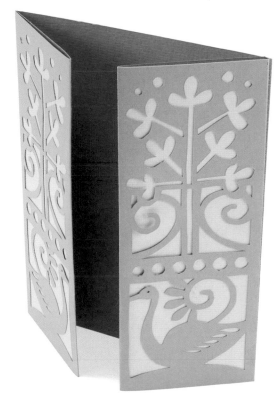

PAPER FOLDS

Fold your paper first in thirds at points B and C, then divide the end panels at A and D to help you to accurately place your templates.

| A | B | C | D |

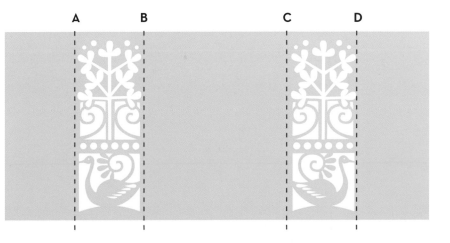

LOVEBIRDS CARD

Why not create a modern interpretation of a classic folded papercut design? With its perfectly symmetrical design of two little lovebirds, this card will bring a smile to any recipient. I attached the motif flat, but you could use foam dots to make it more three-dimensional; just make sure that the foam dots are not visible through the papercut.

Tool kit
- Craft knife and blades
- Cutting mat
- Metal rule
- Invisible tape
- Glue stick
- Spray adhesive
- Bone folder (optional)

Materials
- Template 9 on page 101
- Paper for papercut
- Medium cardstock
- Paper in a contrasting color

Choosing materials
When choosing your paper and card for this project, think about the colors you are going to use. Choosing contrasting colors for the motif and the circle will show off your papercut the best. The card should stand up when it is finished so a medium cardstock is recommended.

1 Cut out template number 9 on page 101. To use the template more than once, or to re-size it, you can photocopy or trace it, following the instructions on page 26.

2 Cut a piece of paper double the width of the template.

3 Fold the paper in half and place the template on top, aligning the dotted line on the template with the folded edge of the paper. Secure the template in position, using invisible tape.

4 Using a craft knife on a cutting mat, cut out the white areas of the template and the paper at the same time (see page 25). Areas that are more tricky or delicate to cut are circled in blue on the thumbnail below. These areas connect the design over the folded edge, so take care not to cut through them.

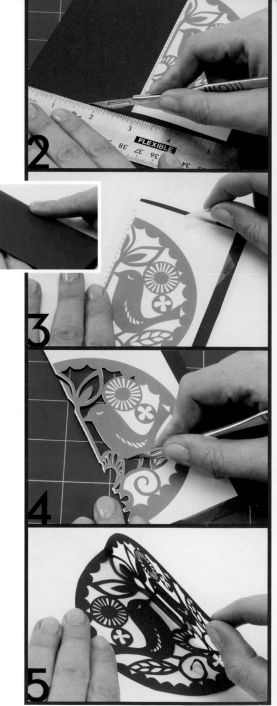

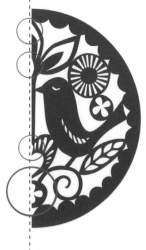

TAKE SPECIAL CARE
Circled in blue are the trickiest areas to cut. Be careful not to overcut the areas on the fold, otherwise the design will not hold together when unfolded.

5 Remove the template and unfold the cut motif. You may want to iron the motif flat at this stage, before you attach it to the card (see page 32), although this is less important if you are going to stick your design flat to the front of a card.

6 Measure out a square that fits around the motif, leaving plenty of room around the edge. Then cut a rectangle that measures two of your squares together from a different color of the cardstock. This will form the main body of your card.

7 Fold the cardstock in half to create the main body of the card. Use a bone folder if you wish.

8 Place the motif on another piece of paper (I used white) and draw a circle around it. Cut out the circle and, using a glue stick, attach it to the front of the folded card, centering it carefully.

9 Spray the back of the papercut motif with spray adhesive, leave it to become tacky, then attach it over the circle on the front of the card.

LOVEBIRDS
In any color, the lovebirds could be an ideal motif for a homemade Valentine's card.

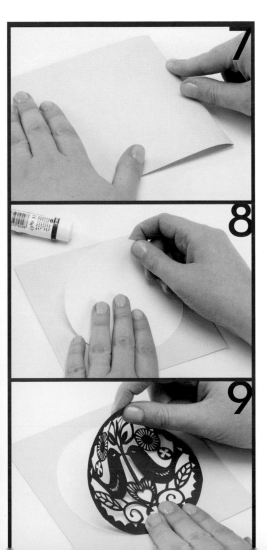

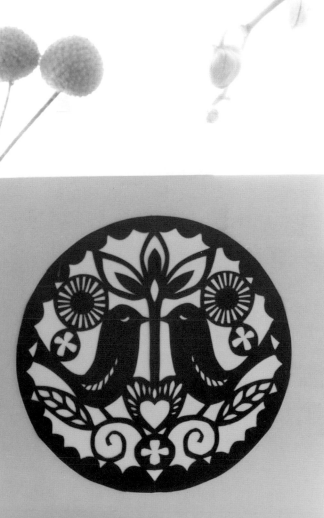

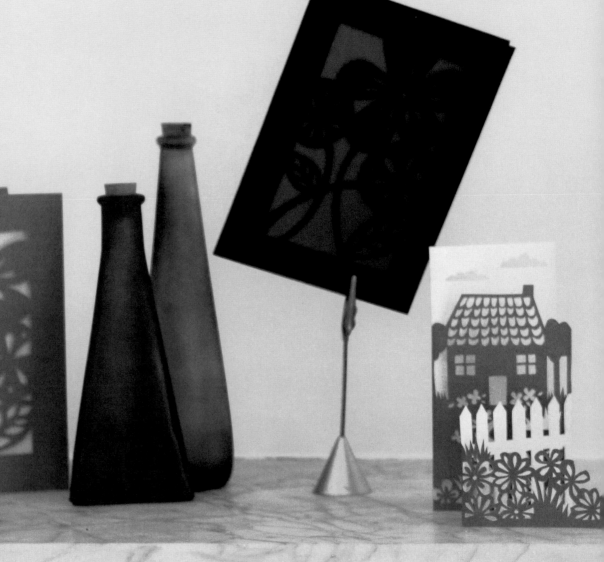

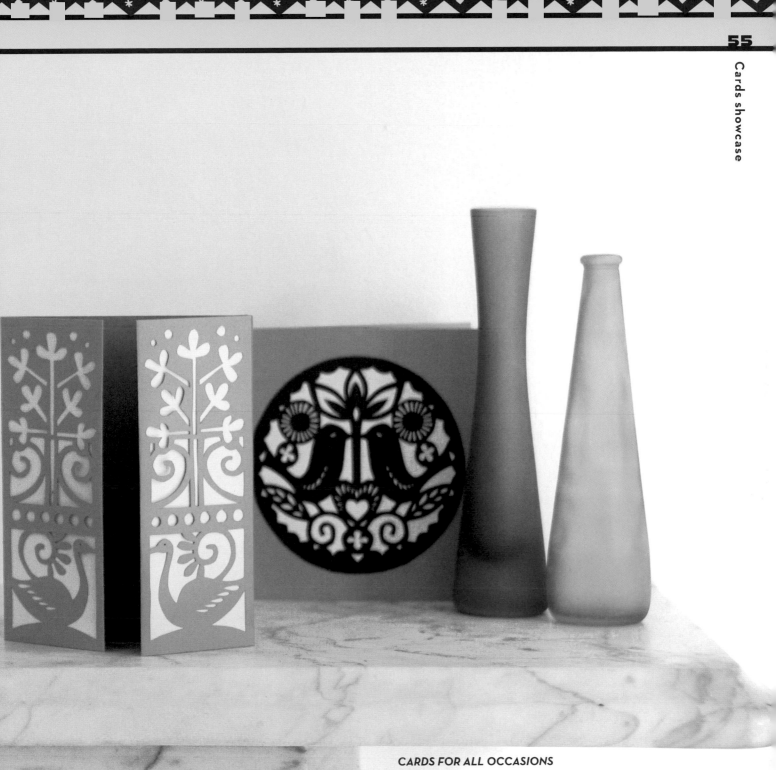

CARDS FOR ALL OCCASIONS
Papercutting is a great technique for creating a huge range of beautiful cards, in many different styles, for all occasions.

Projects

The inspiration for this card came from the many fairy tales that are based in woodlands. You could include characters such as Little Red Riding Hood or the Big Bad Wolf in the design to add another element.

Tool kit
- Craft knife and blades
- Cutting mat
- Metal rule
- Bone folder
- Invisible tape
- Spray adhesive, glue stick, or double-sided tape

Materials
- Templates 6, 7, and 8 on pages 99 and 101
- Selection of colored papers in light, medium, and dark tones
- Cardstock

Choosing materials
When choosing your colors for this card, use three different tones of paper (light, medium, and dark) for the cut-outs, so that you create a sense of depth. It is a good idea to choose a fourth color for the main body of the card—I have used white, which helps the cut-out elements to really stand out. You should use cardstock for the main body of the card so it will be sturdy enough to stand up.

1 Cut out template numbers 6, 7, and 8 on pages 99 and 101. To use the templates more than once, or to re-size them, you can photocopy or trace them, following the instructions on page 26.

2 Cut a piece of cardstock that is the same width and twice the height of the templates. This will form the main body of the card as well as the background to the layered design, so think carefully about what color you are going to use. Using a bone folder and a metal rule, score and fold the card in half (see page 29) to create a landscape-format card.

3 Now choose a different color of paper for each layer of the design. Tape the relevant template onto each paper with invisible tape and, using a craft knife on a cutting mat, cut out the white areas of each layer in turn (see page 25). Once cut, carefully remove each template from its paper.

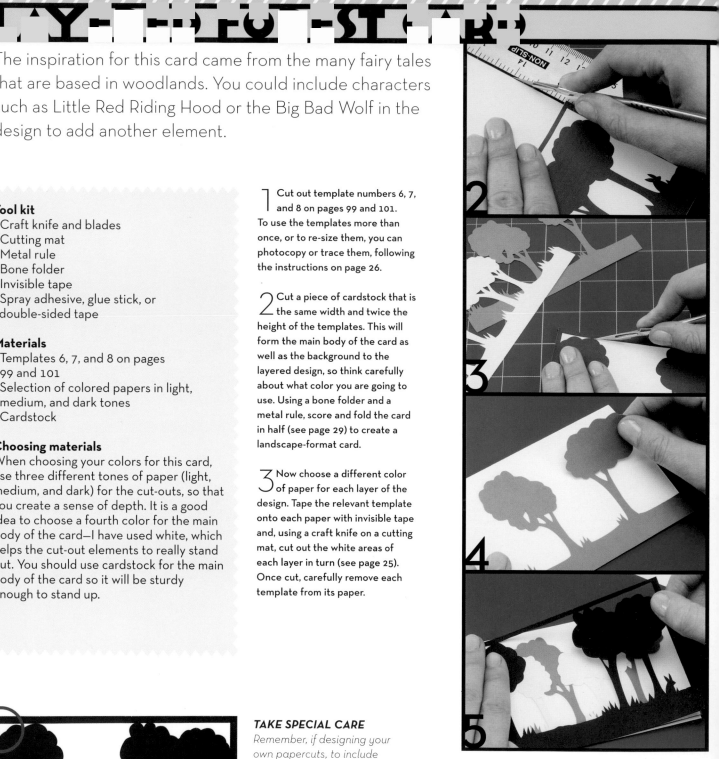

TAKE SPECIAL CARE
Remember, if designing your own papercuts, to include detail, such as the rabbit, and make sure the design is attached to the border on all sides.

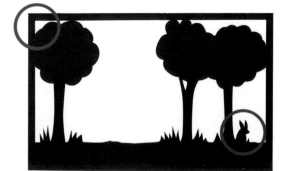

4 Apply your chosen adhesive to the back of the first layer (a lighter-toned papercut) and attach it to the front of the folded card.

5 Repeat step 4, adding first the medium-toned and then the darkest-toned papercut, which includes the border, until the woodland scene is complete.

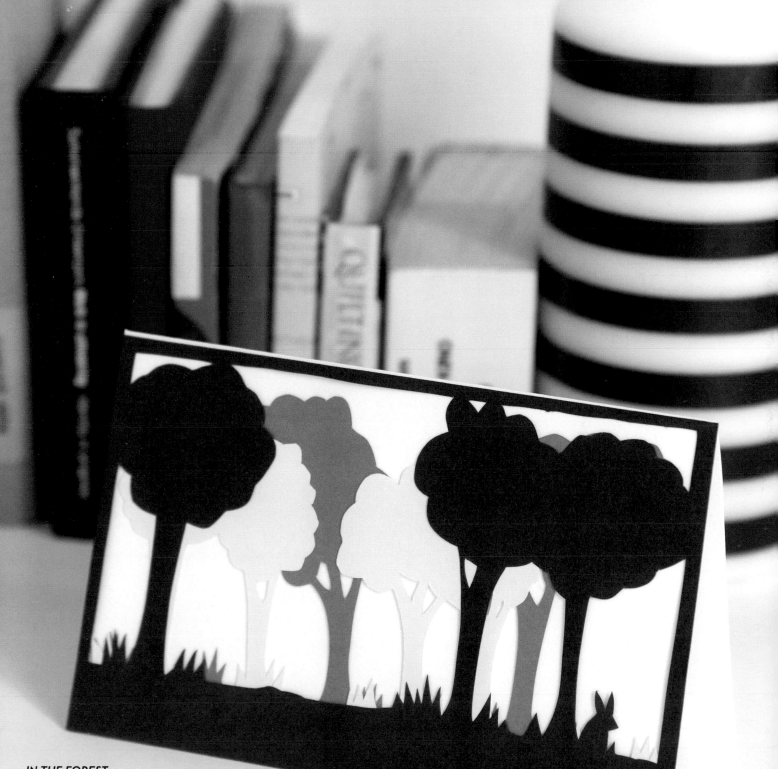

IN THE FOREST
Create a really atmospheric
scene by choosing your colors
carefully, so the layered effect
has maximum impact.

BOTANICAL ARTWORKS

This project will allow you to capture the beauty of a flower or some foliage and treasure it forever in a framed botanical papercut. These designs can be enlarged or reduced to fit any size of frame. As this particular design is folded, remember to consider your paper type before starting (see page 22). You can use these templates to create a botanical bonanza for any room in your home; alternatively, you may want to take inspiration directly from your own garden.

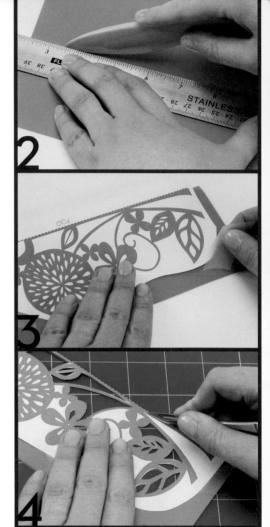

Tool kit
- Craft knife and blades
- Cutting mat
- Metal rule
- Bone folder
- Invisible tape
- Spray adhesive, glue stick, or double-sided tape

Materials
- Template 11 on page 103
- Paper
- Backing paper in contrasting color
- Frame

Choosing materials
When choosing a color palette for this project, you could choose colors that complement the subject, such as earthy or pastel tones. Or, you could create a funky, more contemporary look by using contrasting colors such as vivid pinks or acid yellows. You could even use patterned paper, but make sure the pattern is not so big that it becomes overpowering.

1 Cut out template number 11 on page 103. To use the template more than once, or to re-size it, you can photocopy or trace it, following the instructions on page 26.

2 Cut a piece of colored paper that is the same height and double the width of your template. Using a bone folder and a metal rule, fold it in half (see page 29).

3 Using invisible tape, attach the template to the paper, placing the dotted line of the template on the folded edge of the paper.

4 Using a craft knife on a cutting mat, cut out the white areas of the template and the paper at the same time (see page 25). It is a good idea to start with the folded edge, because this is the area that must stay connected. Next, cut the intricate pieces inside the design, and finally cut around the outline.

TAKE SPECIAL CARE
Circled in red are the trickiest areas to cut. These areas are on the fold so do not cut them too thin, otherwise the design will not hold together when unfolded.

5 Remove the template and open out the paper. The motif may need to be ironed flat at this stage (see page 32).

6 Turn the papercut design over so that the back is facing upward, spray with adhesive, and leave until it is tacky to the touch. If you don't have spray adhesive, a glue stick or small pieces of double-sided tape will work just as well on the less delicate designs.

7 Cut the background paper to the size of the frame. Gently lift up the papercut design and place it in the center of the background paper. Lay it down carefully, smoothing out any creases as you go.

8 Once the papercut is safely attached to the backing paper, place it in the frame.

Tip
Why not create several designs in coordinating colors and hang them on your walls in a group? They will create a focal point in any room and something you can be proud of.

FRAMED ARTWORK
Frame your pieces and use them to create truly personal artworks for your home or as a gift.

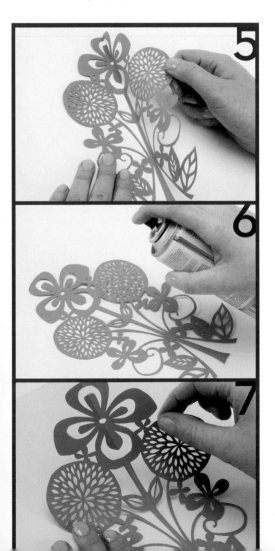

This is a great project to brighten up a room and add another dimension to papercutting. Hang the mobile up and the birds will twist and turn, creating magical shadows on your walls when the sunlight strikes them.

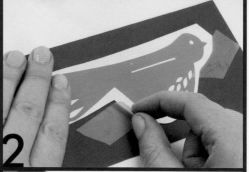

Tool kit
- Craft knife and blades
- Cutting mat
- Metal rule
- Bone folder
- Invisible tape
- Scissors
- Needle

Materials
- Templates 17, 18, and 19 on page 111
- Paper or thin cardstock
- Thread
- Branch or wooden stick
- Fishing wire
- Ceiling hook

Choosing materials
Think about what colors you'd like the birds to be. They could all be the same color, or you could choose a color palette that would suit the room they'll live in. Pastel colors will create a soft, airy feel, while bold, bright colors will be eye-catching and playful. Paper has been used in this example, but thin cardstock would also work well.

1 Cut out template numbers 17, 18, and 19 on page 111. To use the templates more than once, or to re-size them, photocopy or trace them, following the instructions on page 26.

2 Attach the birds' body templates to your chosen paper, using invisible tape.

3 Using a craft knife on a cutting mat, cut out the white parts of the body templates, cutting through the paper at the same time (see page 25). You may find it easier to cut the white details first, and then cut out the main bodies using a pair of scissors.

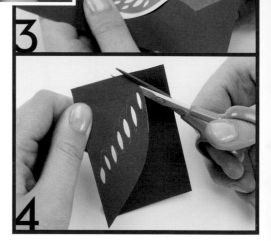

4 Once you have cut out the bodies, tape the wing templates to the paper. Remember, the wings are a folded design, so fold the paper for the wings and align the folds on the templates with the fold in the paper. Cut out the white parts of the wings templates.

5 Next, cut a slit in the birds' backs, as indicated on the templates, so that the wings can slot in.

6 Slip the wings into the slits in the birds' bodies, so that the folds are aligned with the slits, then gently fold the wings upward to keep them in place.

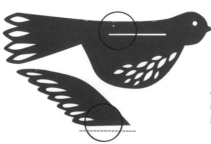

TAKE SPECIAL CARE
Remember the wings are folded so don't cut through the folded edge. Be sure to cut the slit in the body so the wings can be attached.

7 Using a needle, pierce a hole in the birds' bodies, as indicated on the templates. Cut a 20-in. (50-cm) length of thread for each bird and thread it through the hole. Tie a knot in the thread, making a loop around the tops of the birds.

8 To display the birds, find a sturdy branch or a wooden stick. Tie fishing wire to two or three points on the branch, depending on its shape. Tie the ends of all the fishing wires together, leaving a tail long enough to tie around the branch. Hang a hook from your ceiling and the tail of fishing wires to it so that the branch is suspended. Attach the birds to the branch at different heights by tying the thread around the branch.

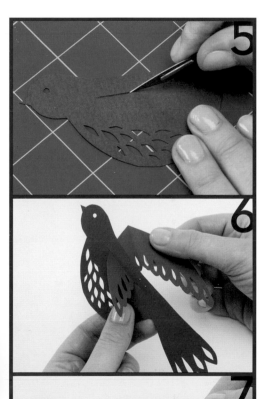

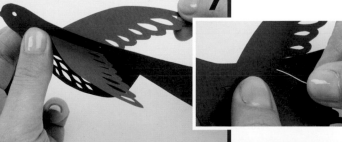

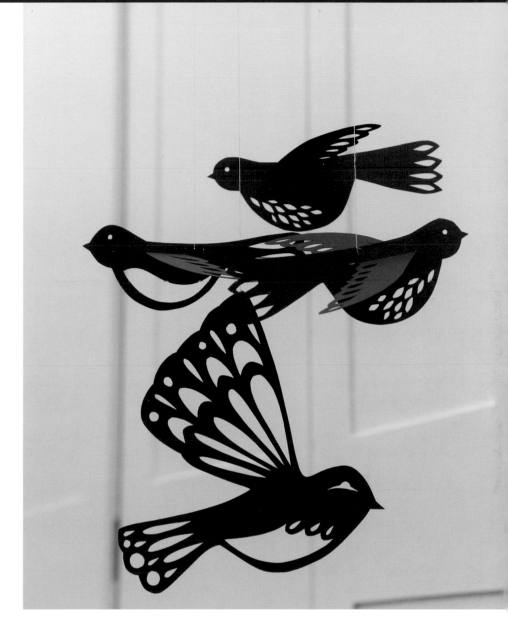

TAKING FLIGHT
The bird mobile could be a beautiful addition to a child's bedroom, or perhaps to bring a touch of nature to your conservatory or porch.

Tip
To create your own mobile, why not design your own papercut pattern on the birds' bodies and wings? You can also play around with color: why not make the birds' wings a different color to their bodies?

Shadow puppets are fairly easy to make and can provide great entertainment for both children and adults alike. Once you have created the shadow puppets, it's up to you to tell a magical story that will take your family and friends on a papercut adventure. With a hare that is the fastest sprinter in the county, a mouse that loves to whisper gossip, and a mischievous squirrel that is always up to something, you are bound to have many a tale to tell!

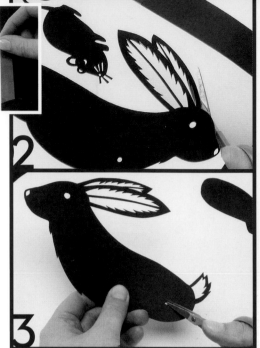

Tool kit
- Craft knife and blades
- Cutting mat
- Metal rule
- Invisible tape
- Scissors

Materials
- Templates 20, 21, and 22 on page 113
- Thin cardstock
- Brass paper fasteners (available from most stationery stores)
- Wooden sticks

Choosing materials
Shadow puppets work best on black cardstock, and these instructions will guide you in attaching the templates to your cardstock and cutting them out. An alternative is to photocopy the templates onto white cardstock to start with and cut them straight out to save you sticking down templates. You could then paint the cutout shapes black afterward.

1 Cut out template numbers 20, 21, and 22 on page 113. To use a template more than once, or to re-size it, you can photocopy or trace it, following the instructions on page 26.

2 Using invisible tape, attach the templates to your chosen cardstock. Using a craft knife on a cutting mat, or scissors, begin to cut out the bodies, legs, and tails, of the puppets.

3 Now cut out any features that you want your puppets to have—eyes, noses, whiskers, or fur details, for example. The final stage of the papercutting is to cut out the holes for the fastenings (shown as small white circles on the templates). Use scissors to cut these small holes.

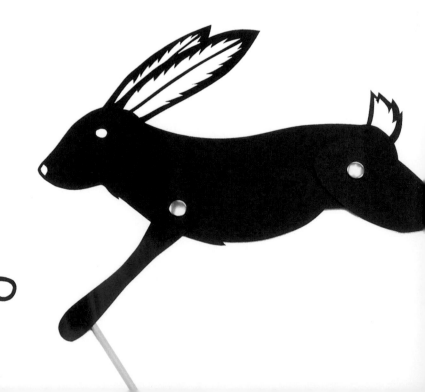

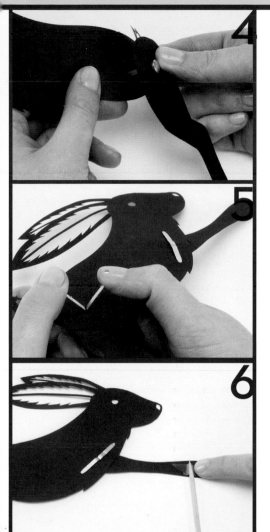

4 Next, attach the hare's legs. Match up the circles on the hare's legs to the ones on its body. Once you have them in place, insert the brass paper fasteners through the circles from front to back.

5 Turn the puppet over and bend back the arms of the fasteners so that the legs are attached to the body. Repeat steps 4 and 5 to attach the squirrel's tail.

6 With the backs of the puppets facing upward, attach the thin wooden sticks to the puppets using invisible tape. You will need one stick for each leg of the hare, one stick each for the tail and the body of the squirrel, and one stick for the mouse.

7 Now all you have to do is practice bringing your puppets to life by maneuvering them with the sticks. To create magical shadows, shine a lamp at your puppets while moving them, to see the animals dance across the room.

Tip
To make a fantastic theater for your shadow puppets, get a big cardboard box, cut out one of the side panels, and replace it with some white fabric or tracing paper, making sure it is as taut as possible. Shine a lamp from behind the puppets onto the fabric or tracing paper. Now the stage is set for you to let your imagination run wild and tell magical stories to one and all.

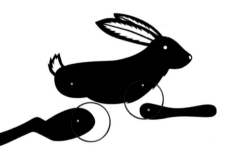

TAKE SPECIAL CARE
Circled in red are the trickiest areas to cut. The holes can be difficult so be careful and make sure they line up so you can place the brass fasteners through.

STORYTIME
Your shadow puppets are now ready for you to really have some fun and enchant your family and friends with nostalgic fairytales.

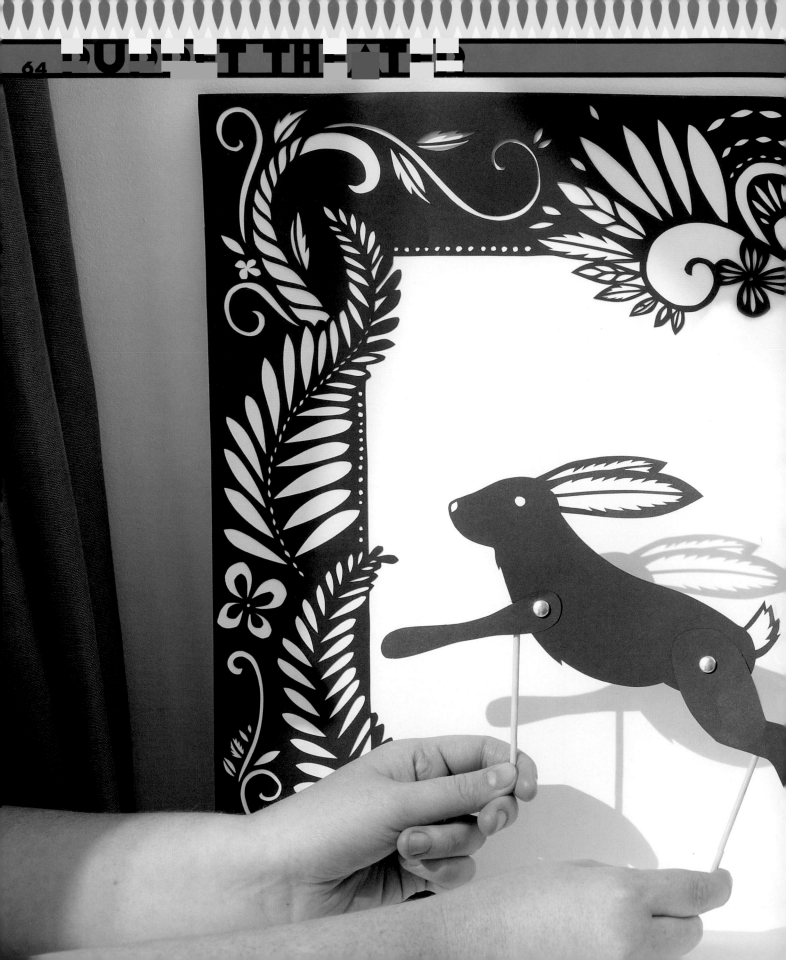

PUPPET THEATER

Follow the instructions on page 63 to create a cardboard theater, or make a papercut frame to perform your stories in, and really get the most from your shadow puppets.

TEALIGHT HOLDERS

Add some beautiful lighting to your dinner table or around your home. These simple papercut tealight wraps add a sense of magic to any occasion and create entrancing shadows that dance around the room.

Tool kit
- Craft knife and blades
- Cutting mat
- Metal rule
- Invisible tape
- Tape measure
- Double-sided tape or glue stick

Materials
- Template 23 on page 115
- Paper
- Glass jars or tealight holder
- Tealight candle

Choosing materials
Any colored paper can be used; the thinner the paper, the more light will be allowed through. I sometimes combine light- and heavyweight papers to create different shadows.

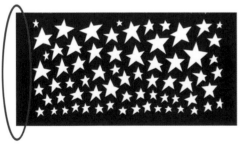

TAKE SPECIAL CARE
You must remember to leave a ³⁄₈-in. (1-cm) space at the end of your design so you have an overlap.

1 You can cut out template number 23 on page 115 for this project, but you will need to check that you have a glass jar that fits. If you don't, then you will have to re-size the template to match your jar (following the instructions on page 26). To do this, measure the height and the circumference of your jar with a tape measure. Then add an extra ³⁄₈ in. (1 cm) to the width measurement.

2 Cut a piece of paper to these measurements and wrap it around your jar to check that it fits snugly and that there is a ³⁄₈-in. (1-cm) overlap .

3 Using invisible tape, attach the template to the paper. (If you are designing your own pattern, remember to leave a ³⁄₈-in./1-cm blank space at each end of the paper.)

4 Using a craft knife on a cutting mat, cut out the white parts of template and the paper at the same time (see page 25). The less you cut, the better: don't cut out more than 50 percent of the paper, because this gives a good balance between light and dark.

5 Apply double-sided tape or glue down one edge of the paper. Wrap the paper around the glass jar and secure by pressing down along the edge to which you attached the adhesive.

6 Place a candle inside the jar, light it, and watch the shadows come to life.

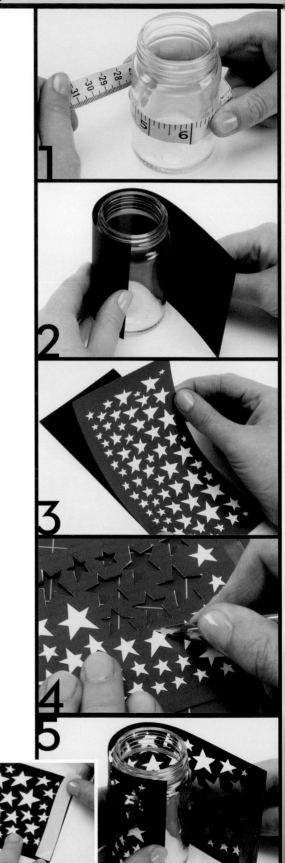

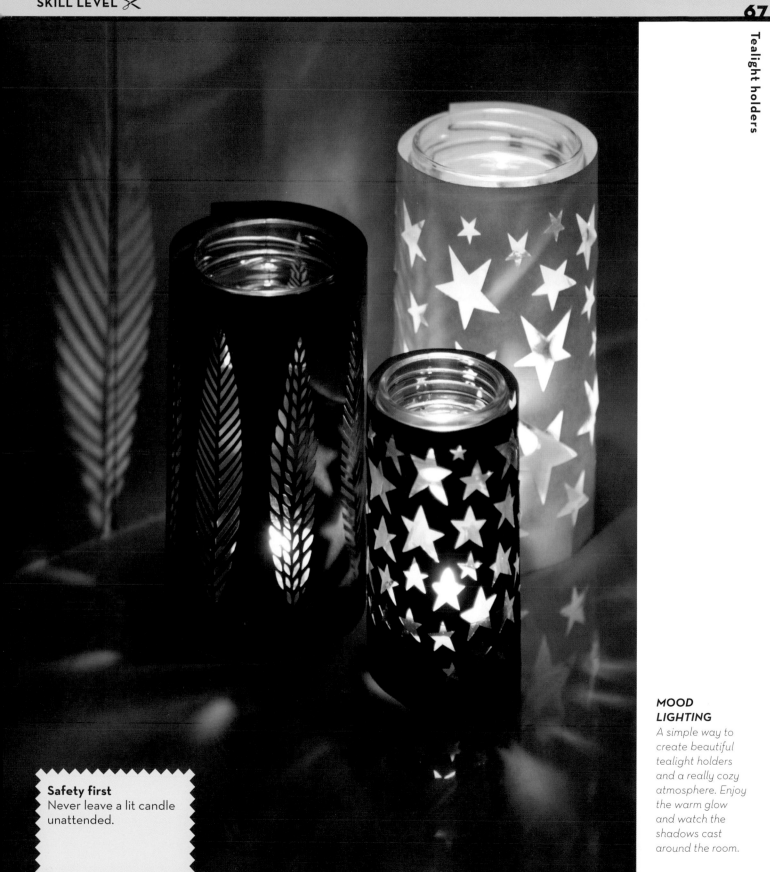

Safety first
Never leave a lit candle
unattended.

**MOOD
LIGHTING**
*A simple way to
create beautiful
tealight holders
and a really cozy
atmosphere. Enjoy
the warm glow
and watch the
shadows cast
around the room.*

PLACE CARDS

If you are going to all the effort of having a lovely party with papercut decorated cupcakes (see page 70), then adding some personalized place cards makes perfect sense.
I have included some simple floral ones and some glass decorations, too, which can also be used as place cards for your guests.

Tool kit
- Craft knife and blades
- Cutting mat
- Metal rule
- Invisible tape

Materials
- Template 26 on page 117
- Thin cardstock

Choosing materials
Using a thin cardstock instead of paper in this project is advised so that your place cards will stand up better. When picking a color, think about the rest of your table settings and choose a color that will complement them.

TAKE SPECIAL CARE
Score and fold along the dotted line, but remember you must not fold the flower design.

1 Cut out template number 26 on page 117. To use the template more than once, or to re-size it, you can photocopy or trace it, following the instructions on page 26.

2 Cut squares the same size as your template from your chosen paper; you need one square for each place card.

3 Using invisible tape, attach the template to the thin cardstock. Using a craft knife on a cutting mat, carefully cut out the white flower details of the template and your cardstock for each place card (see page 25). When you cut out the outline of the flower, remember that you only need to cut one side; this is shown as the white line on the template.

4 Remove the template. Place a metal ruler along the center of the design, across the flower. Using a craft knife or a bone folder, gently score the folding edge on either side of the flower, being careful not to cut through the paper or through the flower design (see page 29).

5 Gently fold the square in half, making sure you do not fold the flower. Press the fold with your fingers or a bone folder to get a sharp crease.

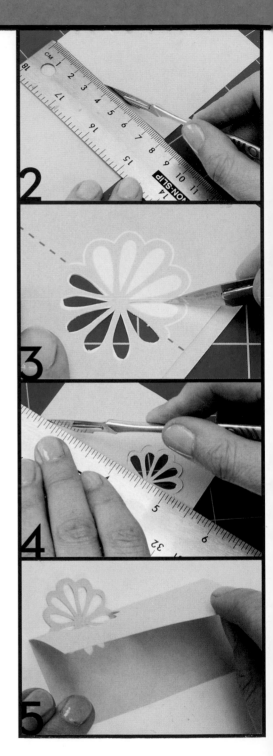

6 Write your guests' names on the cards and place them on the table.

Variation

To make the butterfly decoration, use template 25 on page 117. Attach the template to your paper then fold in half along the dotted line on the template. Cut out the butterfly, taking particular care when cutting on the folded edge, and make a slit in the design along the white line on the template. You could then write your guest's name on one of the wings. Place the slit over the rim of a glass, and slowly pull the butterfly's wings apart to secure it in place.

TABLE EMBELLISHMENTS

These pretty but simple additions add an elegant and personal touch to the table at any dinner party or wedding.

Emily

Add something special to your home baking with some cupcake decorations. These are a great idea for children's birthday parties or for a girly tea party with friends. You can also design your own to go with your own party theme; just follow the basic outline of the cake wrapper, then add your own twist.

Tool kit
- Craft knife and blades
- Cutting mat
- Metal rule
- Invisible tape

Materials
- Template 28 on page 119
- Thin cardstock or paper
- Toothpick
- Cupcakes

Choosing materials
If you would like to be able to use your decorations more than once, use a thick cardstock instead of paper so they will be stronger. It is a good idea to consider the flavor of the cupcake when choosing your color palette, for example, a dark pink wrapper would work well with a raspberry cupcake.

1 Cut out template number 28 on page 119. To use the template more than once, photocopy or trace it. The template in this book will fit a standard cupcake wrapper. If you want to use it to decorate larger or smaller wrappers, you will need to re-size the template before use. See page 26 for advice on this.

2 Attach the template to the cardstock by securing it around the edges with invisible tape.

3 Using a craft knife on a cutting mat, cut out the white parts of the template and the cardstock at the same time (see page 25). These honeycomb sections can be quite fiddly, so take your time. If you are feeling brave, try cutting through two layers of cardstock at once to save time.

4 Once all the details have been cut, carefully cut around the edge. Remember to cut out the slit in the wrapper and the two small lines on the tab (shown as white lines on the template). Slot the tab into the slit to complete the wrapper.

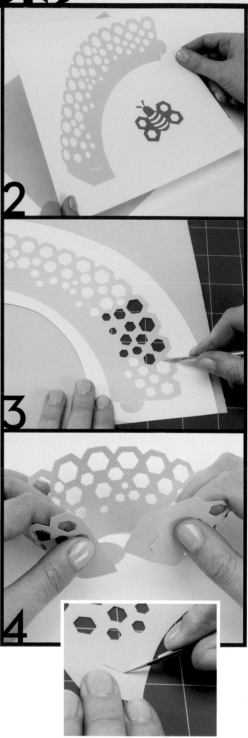

TAKE SPECIAL CARE
Be careful with the slits forming the tab that joins the two ends of the wrapper together.

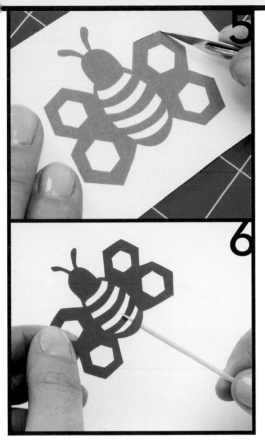

5 Now cut out the bumblebee cake topper part of the template at the back of the book. Again, attach the template to a piece of cardstock with invisible tape and, using a craft knife on a cutting mat, carefully cut out the white sections of the shape.

6 Weave a wooden toothpick in between the stripes on the bumblebee's body, then secure with tiny slivers of invisible tape.

7 Now all you need to do is bake (or buy) some cupcakes, wrap them with your wrappers, and insert the toppers; fill a cake stand with them and enjoy!

TASTY TREATS
You can easily modify this design to suit any kind of party: a kid's birthday, a baby shower, or a summer picnic for example. Use template number 29 on page 121 to make the grass and flowers design.

Projects

This is a great way to add a personal touch to a special gift. Using different-colored papers for the layers adds a lovely contrast as well as a splash of color.

Tool kit
• Craft knife and blades
• Cutting mat
• Metal rule
• Invisible tape
• Scissors

Materials
• Template 30 on page 123
• Cardstock or paper in two colors
• Ribbon

Choosing materials
Any weight of paper can be used for this project, but cardstock works especially well, because it is stronger and more durable than other papers. Think about who is going to receive your gift, what the occasion is (birthday, anniversary, Christmas...), and what motif would be most appropriate.

1 Cut out template number 30 on page 123. To use the template more than once, or to re-size it, you can photocopy or trace it, following the instructions on page 26.

2 Attach the template to the cardstock or paper using invisible tape.

3 Using a craft knife on a cutting mat, cut out the white parts of the template and the paper at the same time (see page 25). Start with the detail inside the tag, then cut the outside edge; you may find it easier to use scissors to do this.

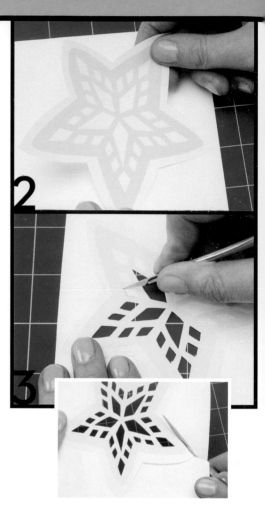

SPLIT LAYERS
The two colored layers will shift and separate slightly, creating a really interesting look.

TAKE SPECIAL CARE
Circled in blue is the trickiest area to cut. The holes at the top of the two layers have to match up to create a neat look when the ribbon is inserted.

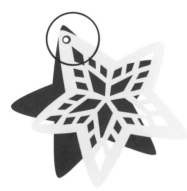

Variation
Rather than leaving the two layers loose, attach the papercut layer to the solid layer with foam sticky pads to add a three-dimensional look to your gift.

4 Repeat steps 2 and 3 using a different color of paper—but this time cut only around the outside shape.

5 Place the papercut tag on top of the solid shape, aligning all edges. Using the point of the scissors or a craft knife, make a small hole through both layers.

6 Thread a piece of ribbon through both layers and attach the tag to your gift.

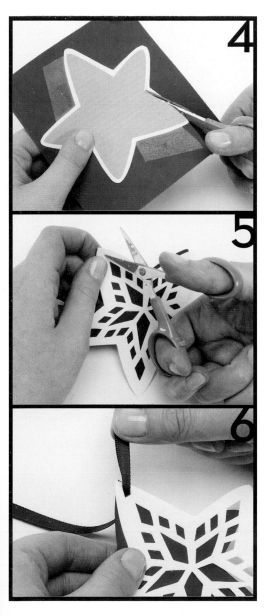

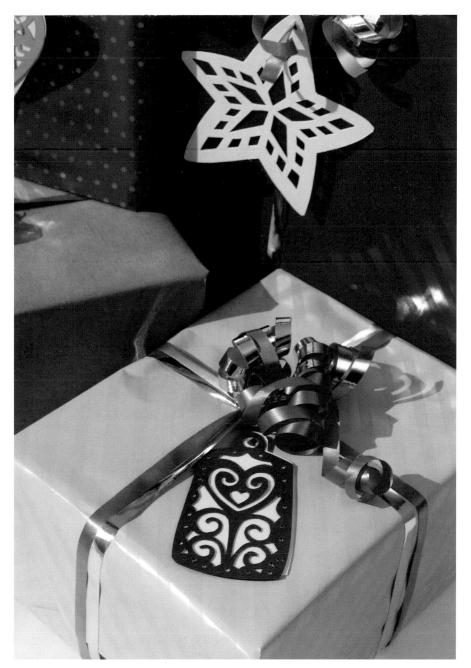

GORGEOUS GIFTS

Choose your shape carefully to suit the occasion (see templates 31, 32, and 33, page 123) and pick colors that complement your wrapping paper choice for the perfect gift.

THE BIRD BUNTING

When celebrating a special occasion, why not decorate your home with a papercut banner? This is a cost-effective way to decorate and adds impact as well as a festive feel. The "flag" template has a solid triangle in the middle that has been left blank, so that you can add your own letters or numbers and spell out a celebratory message. Remember to write backward (see pages 42–43) so that there are no pencil marks on the front of the banner.

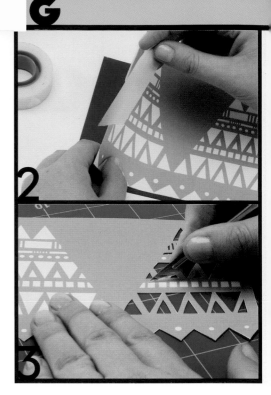

2

3

Tool kit
- Craft knife and blades
- Cutting mat
- Metal rule
- Invisible tape
- Pencil or pen
- Double-sided tape (for bunting)

Materials
- Template 34 on page 125
- Paper
- String or ribbon

Choosing materials
You can use any paper for this project— but if you want to cut out more than one section at a time, use a lightweight paper so that, when you stack the paper, the pile won't be too thick to cut through.

1 Cut out template number 34 on page 125. To use the template more than once, or to re-size it, you can photocopy or trace it, following the instructions on page 26.

2 Cut a piece of paper to fit your template and attach the template using invisible tape around the edges. To cut more than one flag at a time, stack the paper and secure the edges with invisible tape to keep them firmly in place.

3 Using a craft knife on a cutting mat, cut through the template and the paper. Cut out the outline of the banners first, then cut out the smaller details. Remember to cut out the two holes at the top edges of each "flag" of the banner so that you can string them up once finished.

4 Repeat step 3 until you have enough flags to make your banner. You can make it as long as you like.

5 If you are cutting letters or numbers out of your banner, do so at this stage. Remember to turn the flag over so that the back faces upward and write your letter or number backward on the back.

TAKE SPECIAL CARE
Don't forget to cut the holes at the ends of your papercut so you can attach ribbon to create your banner.

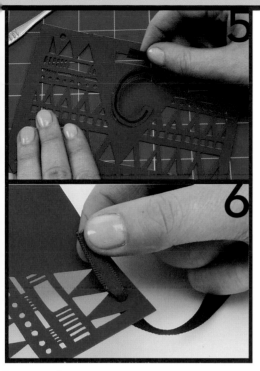

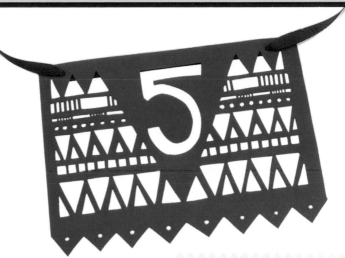

6 Once all the pieces have been cut out, attach them to your string or ribbon. To do this, thread the string or ribbon through one hole and then out through the other. Repeat this process until all the pieces are attached. Remember to leave room at each end of your string so that you can tie your banner to things.

7 Find somewhere in your home to hang the banner—and let the celebrations commence!

PERSONALIZED BANNERS
Letters or numbers are a great way to make a banner more personal. Maybe you could cut each letter of a name or a message into a different flag and spell it out.

Variation
You can also make simple paper bunting to complement your papercut banner. First, cut a series of triangles with room for a folded flap at the top (see template number 36 on page 127). To create the flap, fold the top edge of the triangle over and trim the edges so you don't see the folded-over bits. Next, place a piece of double-sided tape along the inside of the folded edge. Take a length of string or ribbon, peel back the double-sided tape, pull the string taut, place the triangle's flap over the string, and press it shut, enclosing the string inside. Remember to leave a length of string free at each end so that you can hang the bunting up.

PATTERN AND COLOR
Alternate the two designs on page 125 for a lovely repeating pattern. If you cut all of your pieces out of the same paper you can add a splash of another color by choosing a contrasting ribbon.

TEA FOR TWO
Using elements from a number of projects you could throw a charming tea party decorated with your own papercuts.

Sometimes the simplest decorations are the most effective. This snowflake-and-star decoration is just perfect for the Christmas season. Put them in a window or on a tree and let them twist and turn, adding some magic to your home.

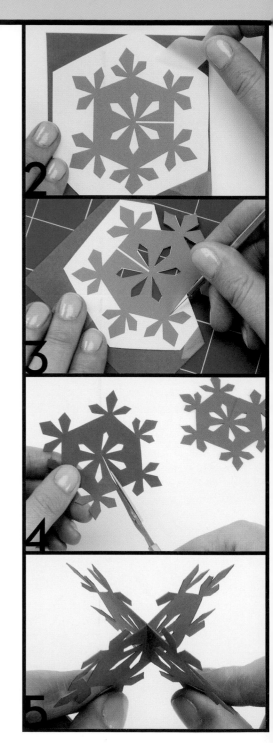

Tool kit
- Craft knife and blades
- Cutting mat
- Metal rule
- Invisible tape
- Scissors
- Needle

Materials
- Template 37 on page 127
- Thin cardstock
- Thread

Choosing materials
Cardstock works well for this project because you want the decorations to be sturdy when they are finished. This will also allow you to use them time and time again, so long as you store them safely.

1 Cut out template number 37 on page 127. **To use the template more than once, or to re-size it, you can photocopy or trace it, following the instructions on page 26.**

2 Attach the template to the cardstock, using invisible tape around the edges.

3 Using a craft knife on a cutting mat, cut the white areas on the template and the cardstock at the same time (see page 25). Take care with the smaller detailed area inside. Repeat steps 2 and 3 so that you end up with two identical cut-out decorations. Alternatively, to cut both decorations at the same time, stack two pieces of cardstock and secure the edges with invisible tape to keep them firmly in place.

4 Now cut a slit in each decoration: on the first decoration, cut a slit from the top down to the center; on the second, cut from the bottom up to the center.

5 Slot one decoration into the other at a 90° angle so that they are locked together.

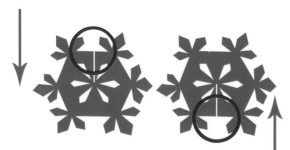

TAKE SPECIAL CARE
Make sure you cut slits in both papercuts so you can slide the two halves together.

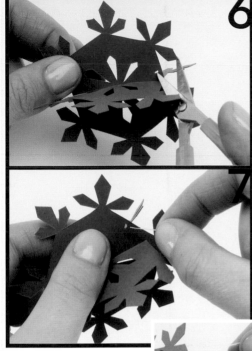

6 Pierce a small hole in the top of your decoration with a needle or a pair of scissors.

7 Thread a length of thread through the hole. Tie the thread securely and hang up your decoration.

Tip
This is a really simple, but very effective, project, so try designing your own snowflakes. Just remember that one slit has to go from the top down and the other from the bottom up, and they will always slot together.

DECK THE HALLS
Hang your finished decorations on your Christmas tree or around your home and live in your own winter wonderland. Try the other templates on page 127 too.

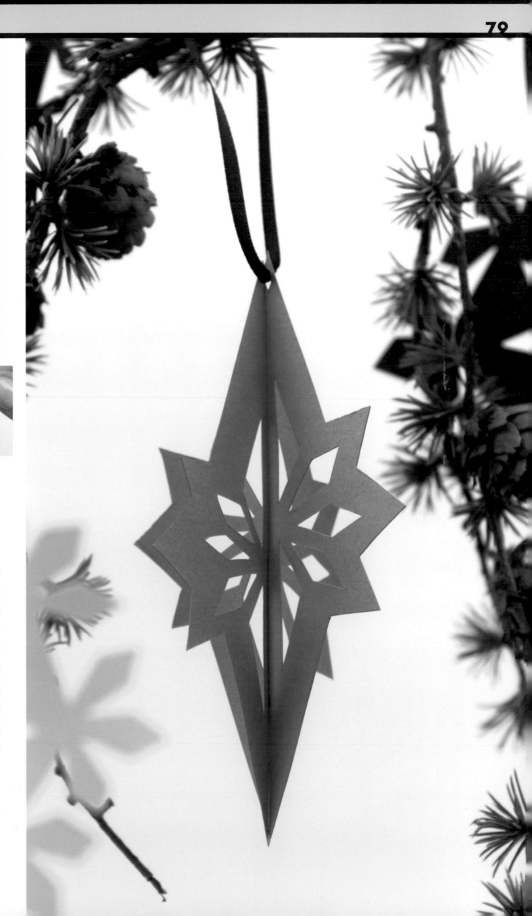

Using papercuts as window decorations is a very traditional way of displaying them; the light shines through the design, creating magical shadows. You could also hang the papercuts from beams in your home, or place them in a frame on your wall. The smaller heart design featured on page 109 (template 16) could also be used as a motif for a card (see pages 52–53).

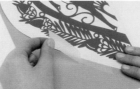

Tool kit
- Craft knife and blades
- Cutting mat
- Metal rule
- Invisible tape
- Needle
- Scissors

Materials
- Template 15 on page 109
- Paper
- Thread or ribbon (optional)
- Double-sided tape (optional)

Choosing materials
Choose a lightweight paper for this project, because it is folded before you cut out the design. Any color paper can be used, since when the sun shines through the window, it will light the papercut from behind and make it really stand out.

1 Cut out template number 15 on page 109. To use the template more than once, or to re-size it, you can photocopy or trace it, following the instructions on page 26.

2 Cut a piece of paper double the width of the template and fold it in half, pressing it with your fingers to create a sharp crease. Attach the template to the paper using invisible tape, remembering to match up the dotted line on the template with the folded edge of the paper.

3 Using a craft knife on a cutting mat, cut out the white parts of the template and the paper at the same time (see page 25). The design is quite complicated, so take your time. Start by cutting the areas in the center around the stag, before moving on to the feathery pine branches around the outside. Take care when cutting along the folded edge, so that the design stays in one piece when you unfold it.

4 Remove the template and unfold the design. You may want to iron the papercut at this stage (see page 32), so that it will hang flat against your window.

TAKE SPECIAL CARE
Circled in red are the trickiest areas to cut. Pay special attention to the difficult areas along the fold, around the stag, and the areas that connect it to the border.

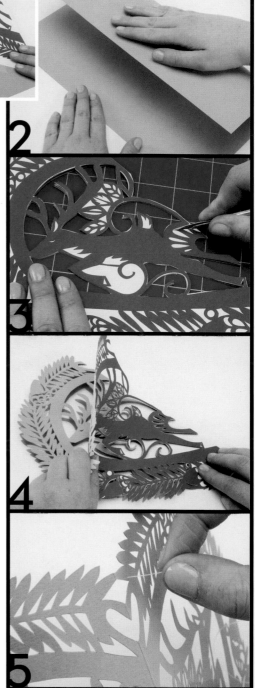

5 Decide how long the hanging thread needs to be, then cut a length of thread twice this length. Fold the thread in half. Thread the folded end through one of the holes in the center top of the papercut, feed the loose ends through the folded end to form a loop, and pull taut. Hang the papercut in your chosen location. You could also attach the papercut to a window with a few small pieces of double-sided tape.

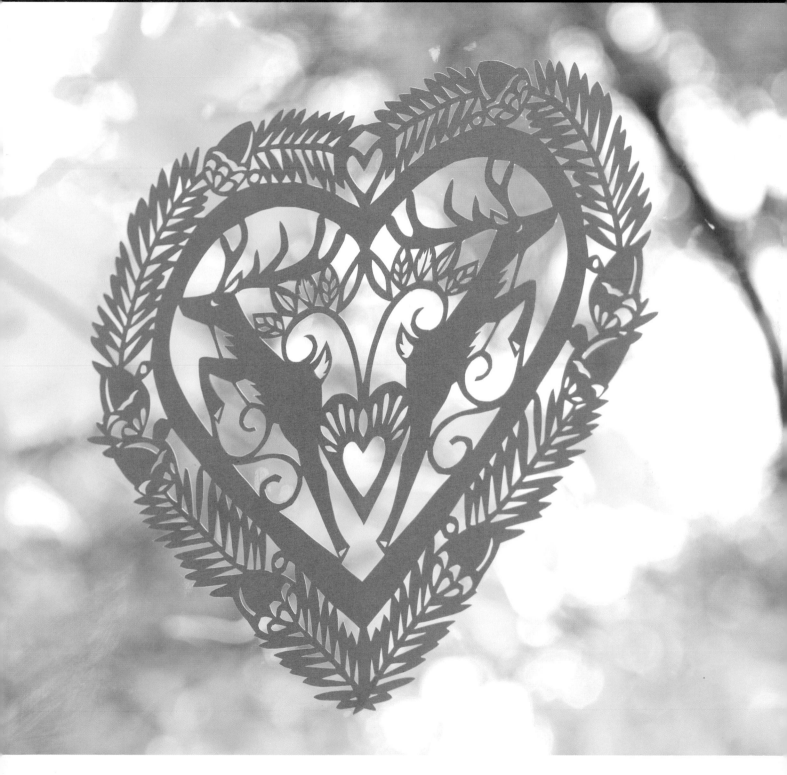

DOUBLE-SIDED ART

A papercut attached to a window like this is a double treat, since it can be enjoyed from inside and outside the house.

This design is a modern interpretation of a traditional folk-art papercut, using bold, contrasting colors. Using two layers adds more depth to your design and is a good way to introduce a secondary color. Place the finished papercut in a frame to create a great piece of original art for your home.

Tool kit
- Craft knife and blades
- Cutting mat
- Metal rule
- Invisible tape
- Double-sided tape or glue stick

Materials
- Template 41 on page 133
- Papers in two contrasting colors

Choosing materials
Choose a different color of paper for each layer, making sure that they contrast. Think about what colors work well together: using black and a bold red, pink, or orange will create a really modern feel. If you want something softer, why not use two lighter colors, such as pale green and pale blue, to create a softer, tonal design. A light- to mediumweight paper is perfect for this design.

1 Cut out both parts of template number 41 on page 133. To use the template more than once, or to re-size it, you can photocopy or trace it, following the instructions on page 26.

2 Choose two contrasting papers and cut each one to double the size of the template, as these are folded designs.

3 Fold the first paper (the one for the top layer) in half and run your finger along the fold to create a sharp crease. Attach the template to the paper with invisible tape, matching up the dotted line on the template with the folded edge of the paper.

4 Using a craft knife on a cutting mat, begin cutting out the white areas of the template and paper at the same time (see page 25). Start with the folded edge and work your way outward. Be patient and take your time with the small areas to avoid mistakes.

5 Once you have cut the first layer, repeat steps 1–4 with the second layer, so that you are left with two papercuts in different colors—the top and the bottom layer.

TAKE SPECIAL CARE
Circled in red and black are the trickiest areas to cut. Don't cut away too much paper along the folded edge. Watch out for the bottom layer fox, you don't want to be able to see the edge once the top layer is in place.

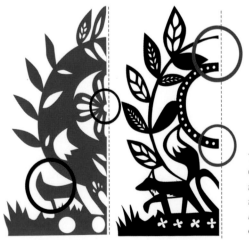

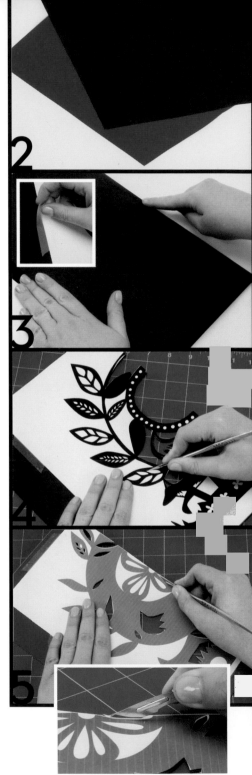

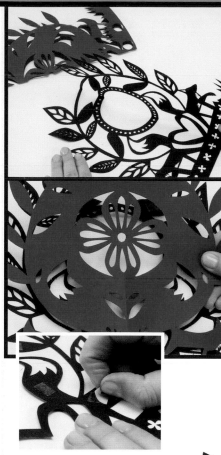

6 Unfold both layers. You may wish to iron the papercuts at this stage before you stick them together (see page 32).

7 Turn the top layer over and place either a few small pieces of double-sided tape or dots of glue on the back (inset). Then turn the second layer over (so that it is facing the same way as the first layer) and carefully place it on top of the bottom layer, taking care to match up the two designs.

8 Turn the design over to see the final result. Now all you have to do is find a frame that will show off your new artwork and hang it on the wall.

FINISHED IMPACT
The delicate design and bold, contrasting colors make this a fantastic, original piece of art, and a great way to show off your papercutting skills.

In the past it was popular to have your profile cut out of paper—a less expensive form of art than having your portrait painted. Today, these silhouettes have a lovely quaint charm about them. Why not cut a silhouette for each member of your family, as an alternative to photographs?

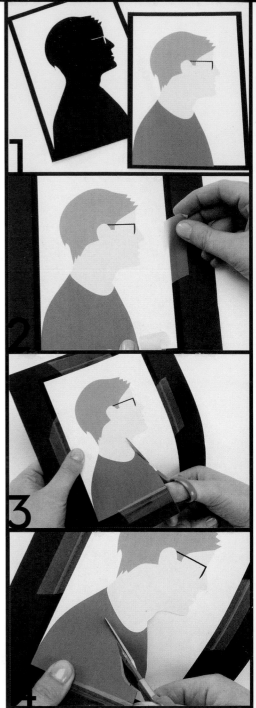

Tool kit
- Craft knife and blades
- Cutting mat
- Metal rule
- Invisible tape
- Scissors
- Spray adhesive

Materials
- Photograph of subject (optional)
- Template 43 on page 135 (optional)
- Frame
- Black paper for silhouette
- Contrasting backing paper

Choosing materials
There are two generic templates on page 135 (templates 44 and 45), where you can add your own hair details and features to personalize them without taking a photograph. Think about what paper you use: for example, rather than the traditional black, you could use a light patterned paper on a dark background.

1 First, take and print a photograph of your subject. Have him or her stand in front of a plain background, facing sideways so you can see their profile. Here, we demonstrate with a simplified graphic. If your subject has long hair ask her to tie it up in some way, since this will give you a better silhouette. You may also want to re-size the photo to fit your frame; this can be done on your computer or on a photocopier. Alternatively, cut out, photocopy, or trace template number 43 on page 135 (see page 26 for advice on this).

2 When you are happy with the size and composition of your photograph (or template), attach it to colored paper (black works best) using invisible tape.

3 Using either scissors or a craft knife, carefully cut around the profile of your subject, including any small details such as hair, eyeglasses, and so on.

4 Once you have cut around the edge of your image, you might want to cut a more interesting line below the neck of your subject; this makes it look more finished. Remove the photo and you will be left with a silhouette on the black paper.

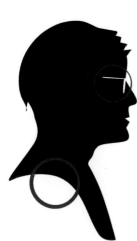

TAKE SPECIAL CARE
Don't forget to include some small details and create an interesting line to finish the bottom edge.

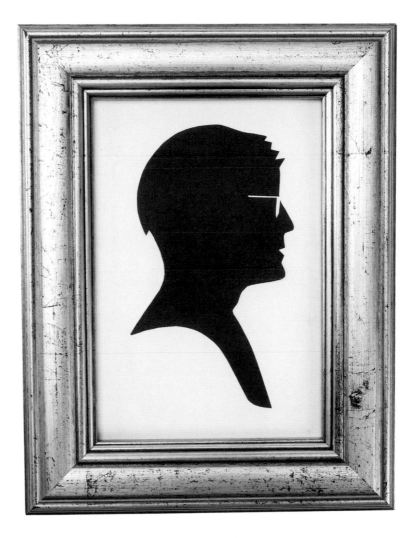

5 Choose a backing paper that contrasts in color or pattern with the silhouette and cut it to the size of your frame.

6 Apply a small amount of spray adhesive to the back of the silhouette. Carefully attach the silhouette to the center of the backing paper.

7 Now place the silhouette in the frame and hang it on your wall. Repeat the process until you have covered all members of your family— and when you have finished, you can start with your friends and pets, too!

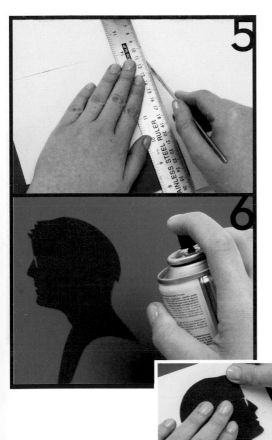

SIMPLE AND GRAPHIC

The simplicity of the outlines and the contrast of the black silhouette on the white background produces an artwork that's really high impact, especially when a few are displayed together.

Tips
- Before you start, it is advisable to have your frame ready and to make sure your photo or template fits. If not, alter the size accordingly
- Rather than just creating profiles of people, think about adding in pets or inanimate objects, too. This will create more of a feature on your wall and give a more modern twist.

This project allows you to add a personal touch to a photograph or picture. You may want to scale up the template, so that it fits a particular frame or picture; you can do this on a photocopier or a computer.

Tool kit
- Craft knife and blades
- Cutting mat
- Metal rule
- Invisible tape
- Spray adhesive, glue stick, or foam sticky pads

Materials
- Template 46 on page 137
- Paper
- Thick cardstock for the backing board
- Frame (optional)

Choosing materials
Choose a colored paper that will suit the image you would like to frame. The weight of the paper doesn't matter, because you will be attaching the finished frame to some backing board.

1 Cut out template number 46 on page 137. To use the template more than once, or to re-size it, you can photocopy or trace it, following the instructions on page 26.

2 Attach the template to your chosen paper using some invisible tape.

3 Using a craft knife on a cutting mat, starting from the center and working outward, begin cutting out the white areas of the template and your paper at the same time (see page 25). Take your time: if you rush you are more likely to make a mistake.

4 Once you have cut out the detail, cut around the edges so that you are left with a frame.

TAKE SPECIAL CARE
Circled in red are the trickiest areas to cut. Small details can be tricky so take your time over the foliage and make sure your pattern is properly connected to the outside edge.

Tip
You could stick your papercut frame to the edges of a mirror to give it a delicate border. The corner motif can be used in this way, too, or to decorate the edge of a photo in a photo album or on a photo card.

5 Now make a backing board from a different color of cardstock. Cut a piece of cardstock that is the same size as your frame.

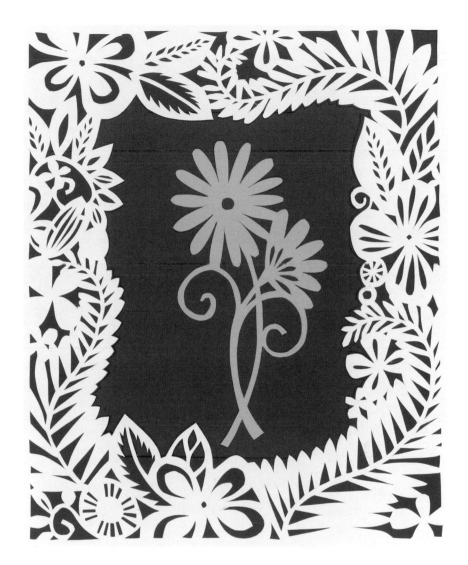

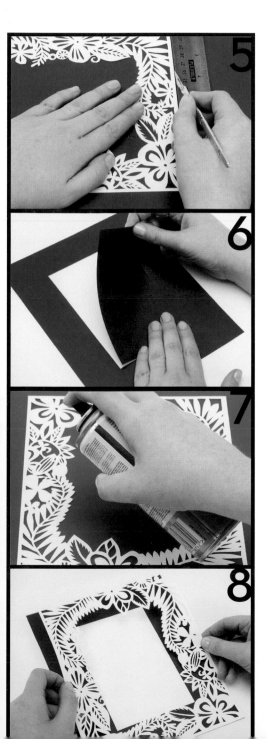

6 Cut out a square in the middle of the board that lines up with the center window in your frame.

7 Turn the papercut frame over and apply adhesive to the back. Spray adhesive works best, but you can use a glue stick or foam pads.

8 Turn the papercut frame over and attach it to the backing board, being careful to align the edges.

9 Place your chosen picture behind the frame and secure it with tape.

PERSONAL TOUCHES

Use the corner motifs or full frame templates on pages 137 and 139 to add your own beautiful adornments to a mirror, a piece of art, or a special photograph.

CITY SKYLINE

The inspiration for this design came from the city of New York. When walking around the streets, I kept looking up at the magnificent skyscrapers and thought that a papercut skyline would be a great way to capture some of this city's magic. This design can either be left flat or folded like the accordion card on pages 48–49 to create a more three-dimensional image that would look great on a mantelpiece or shelf.

Tool kit
• Craft knife and blades
• Cutting mat
• Metal rule
• Invisible tape

Materials
• Template 40 on page 130
• Thin cardstock (preferably black)

Choosing materials
This design should stand up when it is finished, so it is best to use a thin cardstock rather than paper. Black works really well for the skyline, but you could use any other color you like.

1 Cut out template number 40 on page 130. To use the template more than once, or to re-size it, you can photocopy or trace it, following the instructions on page 26.

2 Cut a piece of thin cardstock to fit your template. Using invisible tape, attach the template to the card.

3 If you would like your design to remain flat, then don't fold it. Otherwise, fold the card along the dotted lines of the template (or into quarters if you are not using the template to create the accordion fold), running your finger along the fold to make a sharp crease. Unfold the card.

4 Using a craft knife on a cutting mat, begin cutting out the white areas of the template and card (see page 25). The small windows in the buildings will take some time and expect some overcutting.

5 Once you have cut out all the details, cut the skyline itself.

TAKE SPECIAL CARE
The areas circled in red fall where the design will be folded, so take particular care as you work on these parts.

6 Once the whole design has been cut, gently re-fold it, taking great care not to tear your cutting. By folding and unfolding your paper in step 2 you make this stage much easier. Now you can place it on a shelf!

URBAN ART
You could display your city skyline in a frame or as a standing piece of art, or give it as a greetings card.

Tips
- With this design, it doesn't really matter where you start: if you prefer, you can cut the skyline first and then the details.
- This design could also be made into a greetings card. Attach a small square of white paper to the back of your papercut so you can write your message. Alternatively, a silver pen is a great way to write on black card.
- You could recreate your own city by picking out some key landmarks and mixing them in among buildings and foliage.

This is a great project to attempt once you have become confident in papercutting. You can cut or trace it straight out of the book, but to get the full effect of the design, enlarge the template to $8\frac{1}{4}$ x $11\frac{1}{2}$ in. (210 x 297 mm/A4) or even $11\frac{1}{2}$ x $16\frac{1}{2}$ in. (297 x 420 mm/A3) so that you can create a large papercut perfect to hang on your wall.

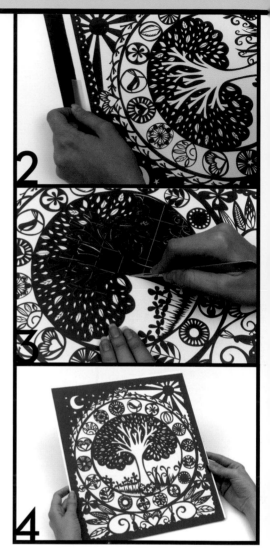

Tool kit
- Craft knife and blades
- Cutting mat
- Metal rule
- Invisible tape
- Spray adhesive

Materials
- Template 50 on page 141
- Paper
- Mount board

Choosing materials
As this is a large design, with some very detailed areas, using paper rather than cardstock is recommended. If you are going to use a backing board, consider what color this is going to be when you choose your paper. White always works well, but a contrasting color could also be quite dramatic and add a different feel to your artwork.

1 Cut out template number 50 on page 141. To use the template more than once, or to re-size it, you can photocopy or trace it, following the instructions on page 26. This design would benefit from being enlarged to create a more impressive piece of wall art for your home, so photocopy the template and then enlarge it to the required size.

2 Using invisible tape, attach the template to your chosen paper.

3 Using a craft knife on a cutting mat, begin cutting out the white areas of the template and your paper at the same time (see page 25). Work systematically: start in the middle and work your way outward.

4 Spray the back of your papercut with spray adhesive, carefully stick to your mount board, and allow to dry. Place the mount board in a frame, hang it on the wall, stand back, and admire.

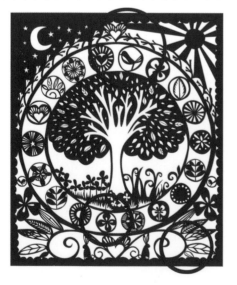

TAKE SPECIAL CARE
This is a complex design, and circled in red are some areas to watch out for. There are some very intricate details in this papercut so don't rush, and make sure all the areas are securely connected to each other.

Tip
With a design this size, it is important to take your time: rather than attempt to cut it all out in one go, you may want to put it to one side for a few days. Just remember to store it flat.

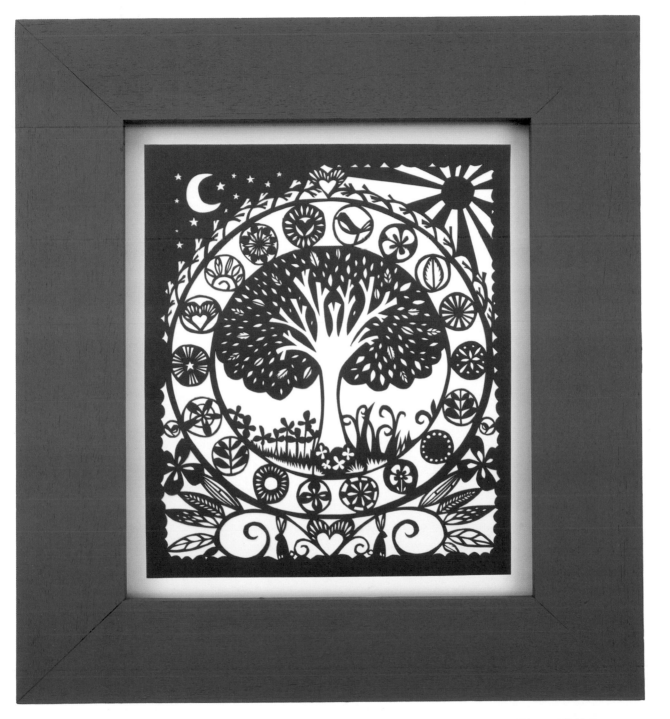

CUSTOM ARTWORK
Once finished you will have a unique piece of art that will really show off your papercutting skills.

TEMPLATES

If you've been wondering when you were going to get to cut up this book, well here it is—the template section. You'll find more than 50 beautiful and unique templates in this section, which you can cut straight out of the book ready to begin your papercutting.

A dotted line is marked down the edge of each page to show where you could cut. Use a metal rule, cutting mat, and craft knife to do this. Many of the pages have more than one template so you might want to use a pair of scissors to cut out the individual templates as you need them rather than removing the whole page.

If you don't want to cut up this book then you don't have to! You can trace or photocopy the templates so you can re-size or modify them and keep them in the book to use again and again. You'll find instructions for how to do this on page 26.

Every template is numbered so you can easily find the right template for the project you are working on. On pages 106 and 130 you will have to fold out the pages to reveal the whole of these special panoramic templates. There are lots more templates than projects so you can choose from a huge range of designs and variations. Every extra template has a reference to a project that uses the same techniques so you can follow the steps to keep you on track.

TEMPLATE 1
Floral single-fold card, pages 46–47.

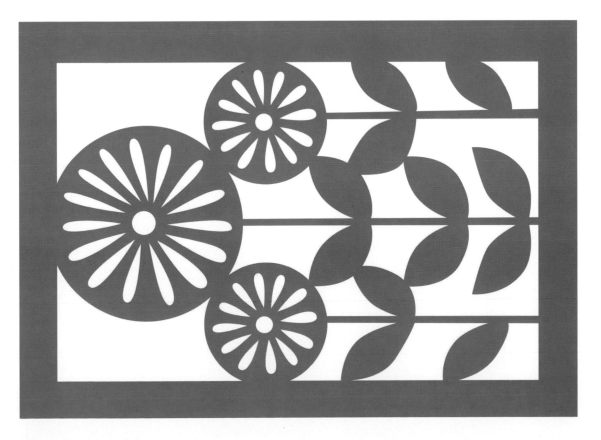

TEMPLATE 2
Floral single-fold card, pages 46–47.

TEMPLATE 3
Folk-art gatefold card, pages 50–51.

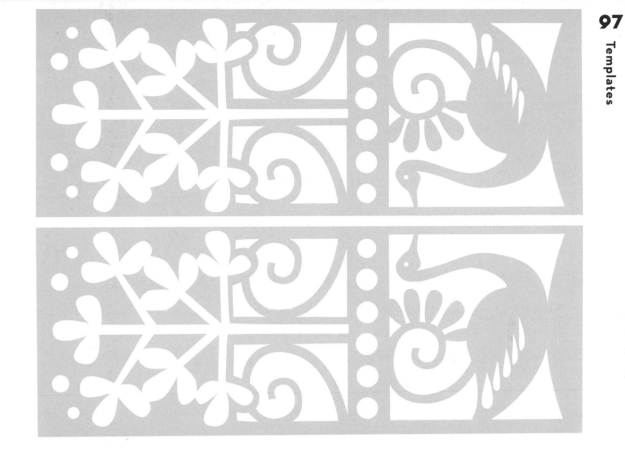

TEMPLATE 4
Folk-art gatefold card, pages 50–51.

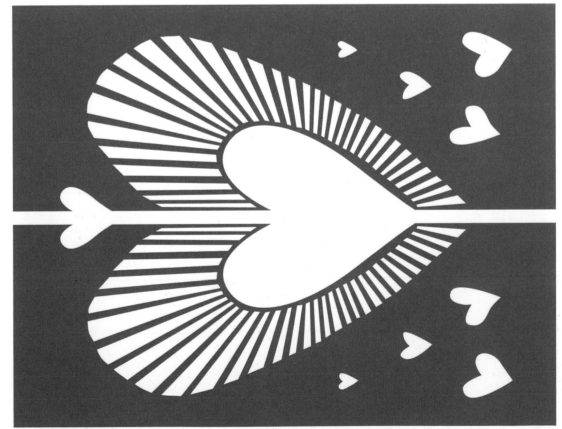

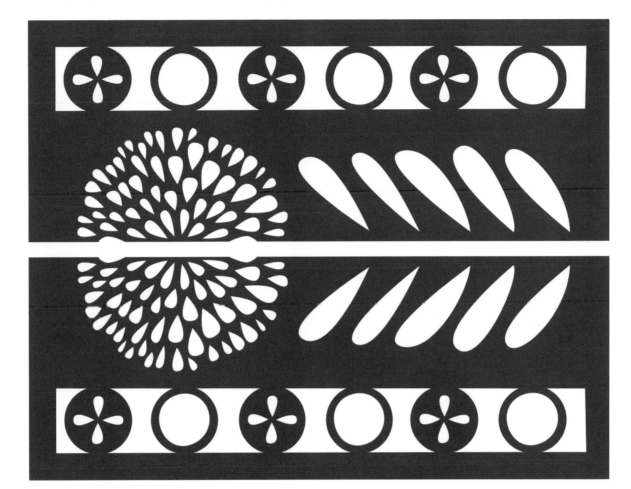

TEMPLATE 5
Folk-art gatefold card, pages 50–51.

TEMPLATE 6
Layered forest card, pages 56–57.

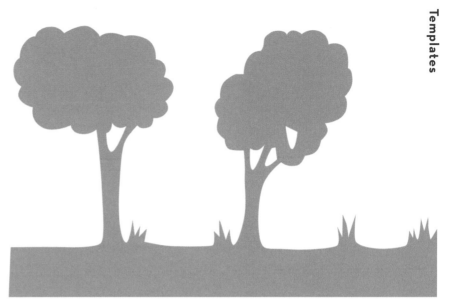

TEMPLATE 7
Layered forest card, pages 56–57.

TEMPLATE 9
**Lovebirds card,
pages 52–53.**

TEMPLATE 8
Layered forest card, pages 56–57.

TEMPLATE 10
**Lovebirds card,
pages 52–53.**

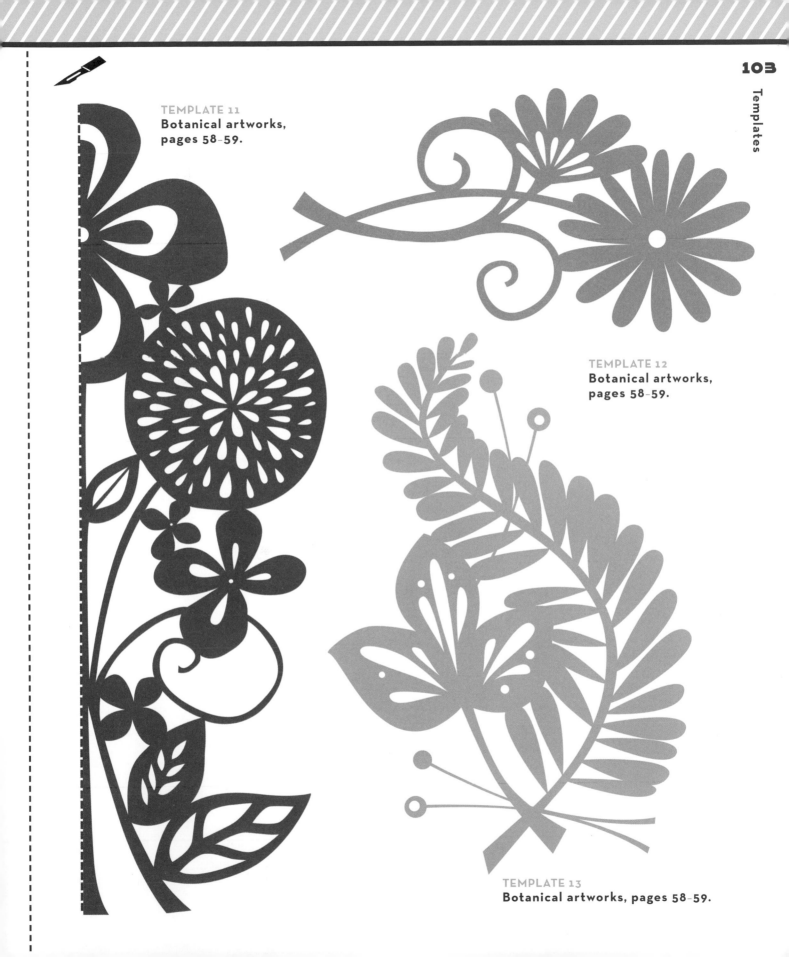

TEMPLATE 11
**Botanical artworks,
pages 58–59.**

TEMPLATE 12
**Botanical artworks,
pages 58–59.**

TEMPLATE 13
Botanical artworks, pages 58–59.

FOLD OUT
THE FLAP

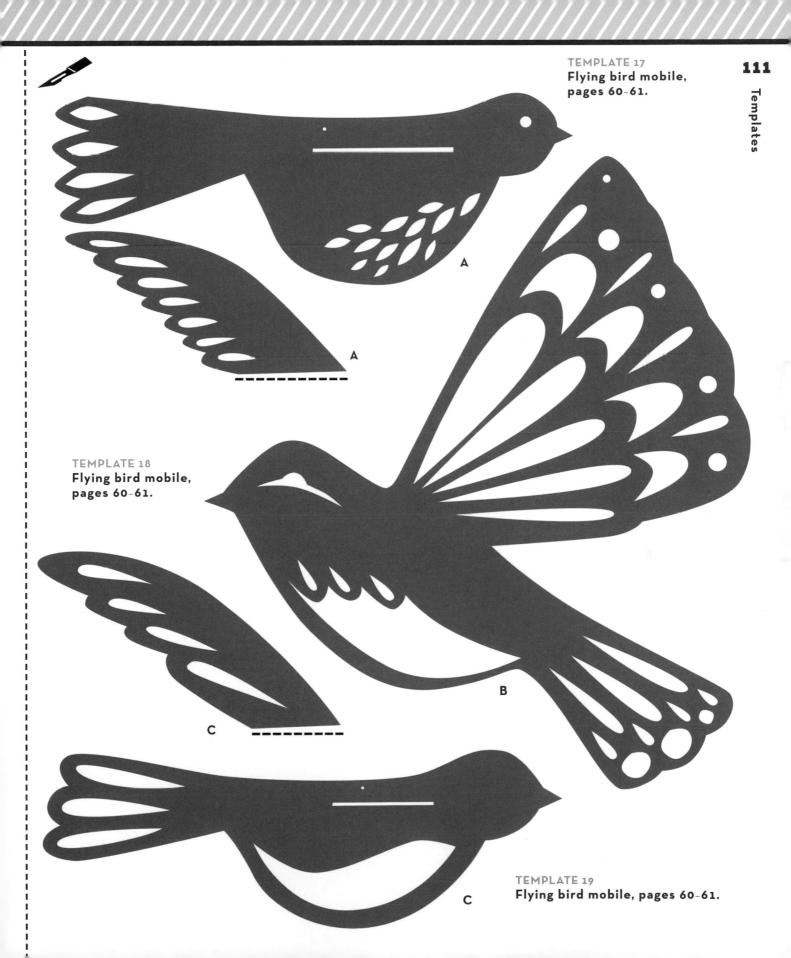

TEMPLATE 17
**Flying bird mobile,
pages 60–61.**

A

A

TEMPLATE 18
**Flying bird mobile,
pages 60–61.**

B

C

TEMPLATE 19
Flying bird mobile, pages 60–61.

C

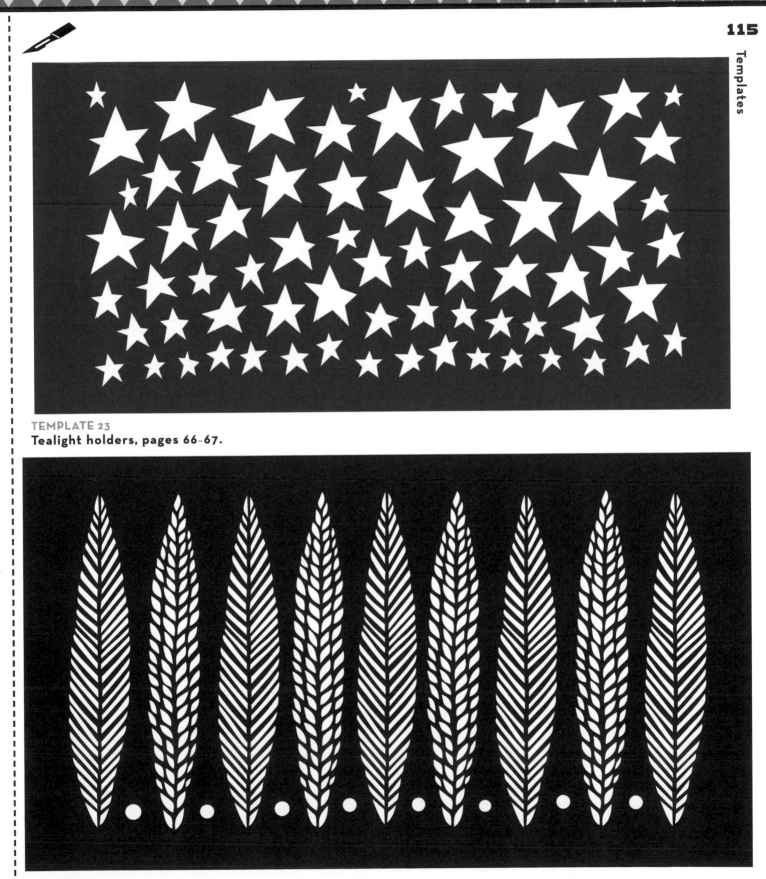

TEMPLATE 23
Tealight holders, pages 66–67.

TEMPLATE 24
Tealight holders, pages 66–67.

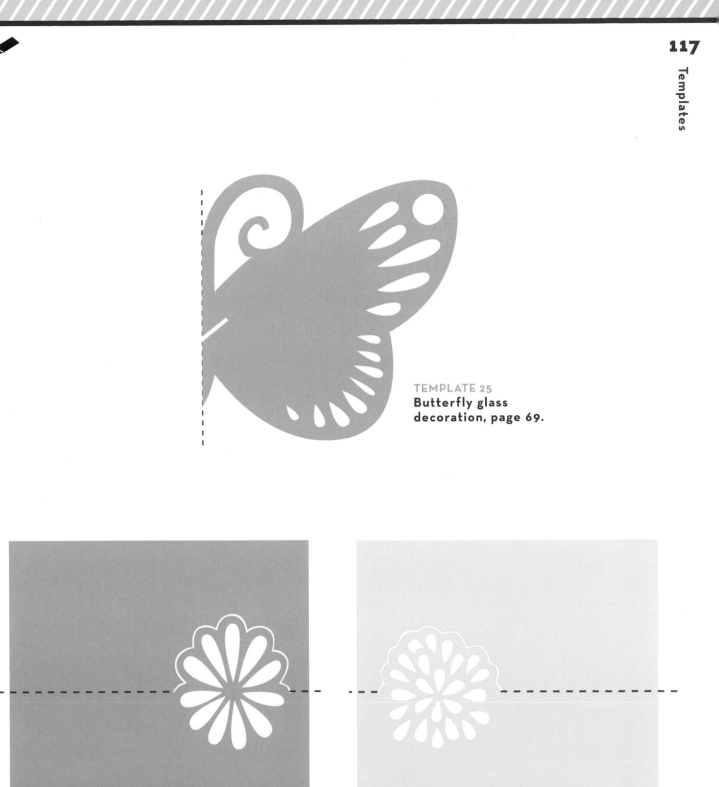

TEMPLATE 25
**Butterfly glass
decoration, page 69.**

TEMPLATE 26
Place cards, pages 68–69.

TEMPLATE 27
Place cards, pages 68–69.

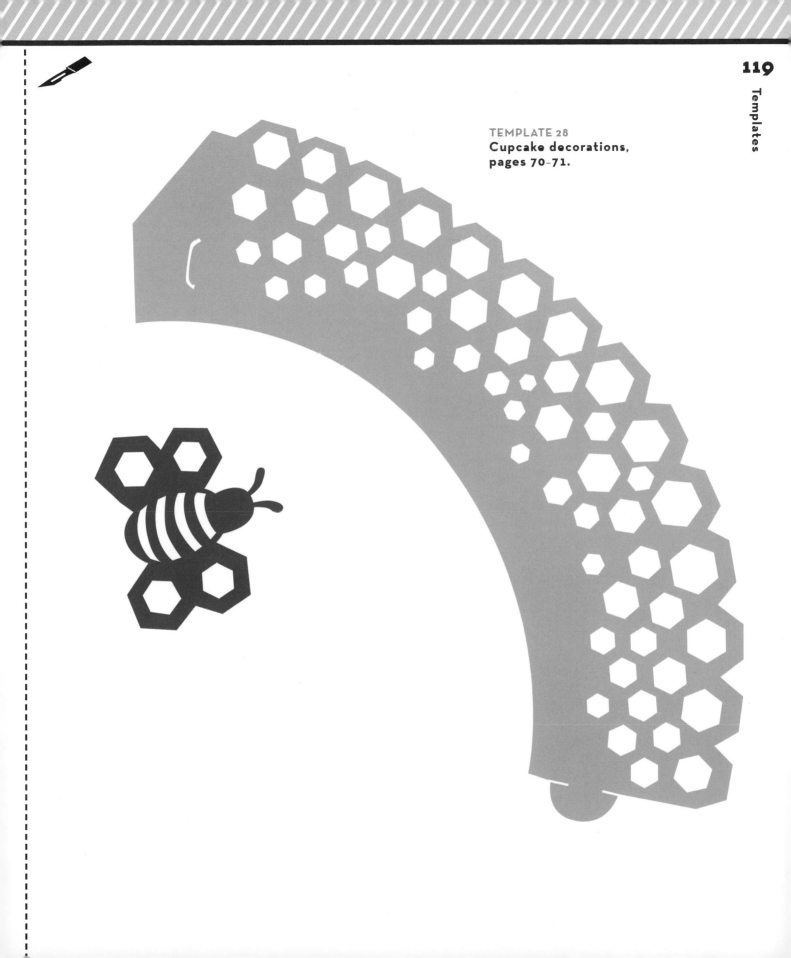

TEMPLATE 28
**Cupcake decorations,
pages 70-71.**

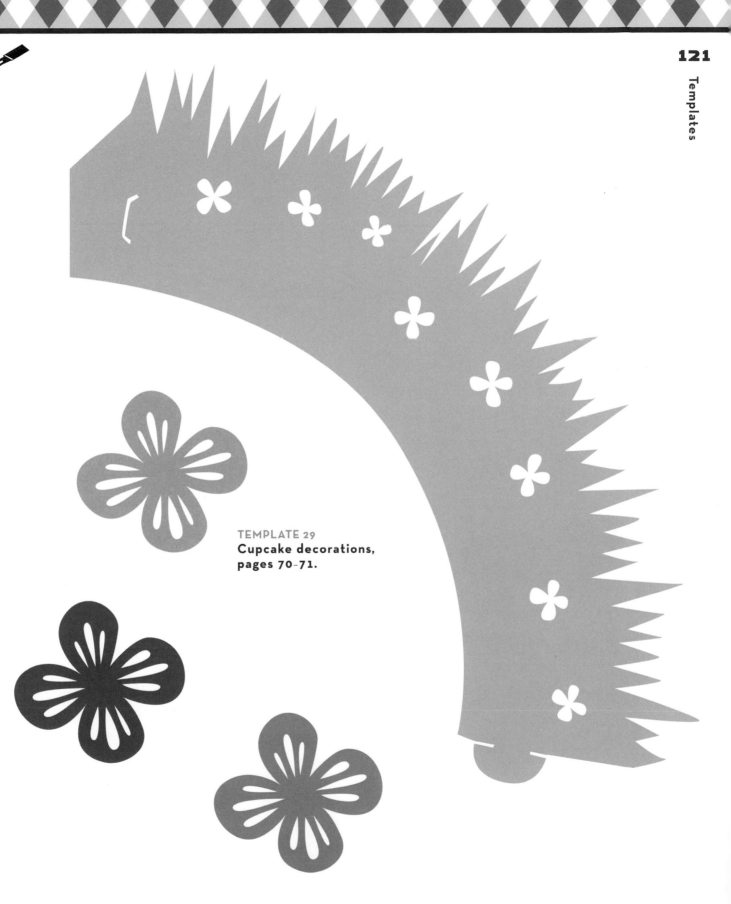

TEMPLATE 29
**Cupcake decorations,
pages 70–71.**

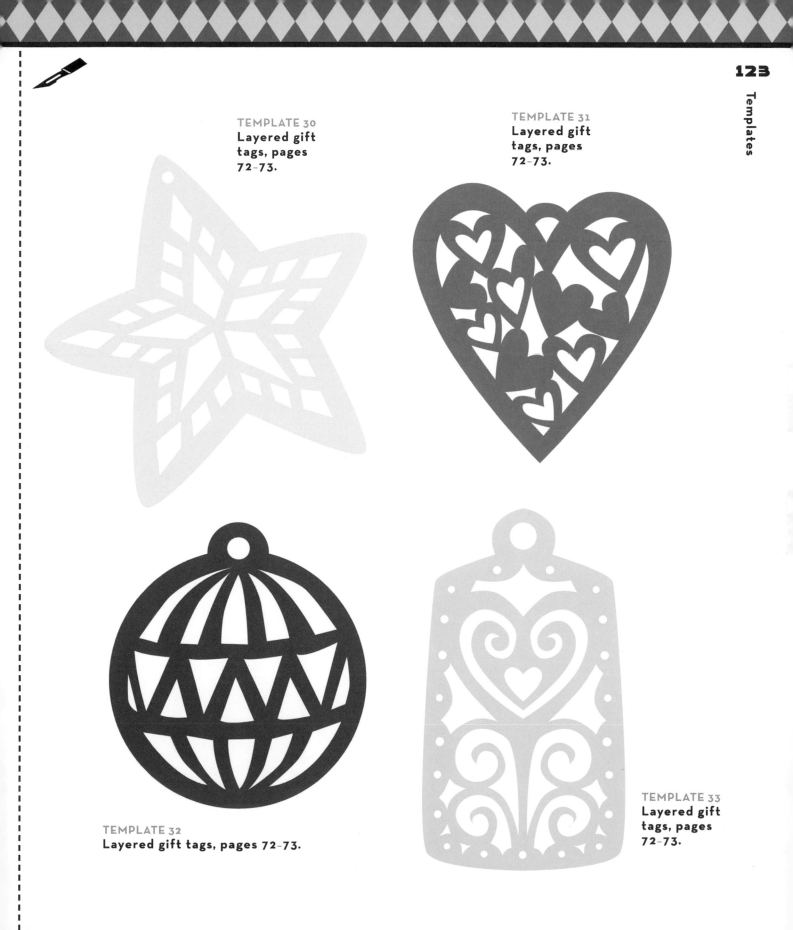

TEMPLATE 30
**Layered gift
tags, pages
72–73.**

TEMPLATE 31
**Layered gift
tags, pages
72–73.**

TEMPLATE 32
Layered gift tags, pages 72–73.

TEMPLATE 33
**Layered gift
tags, pages
72–73.**

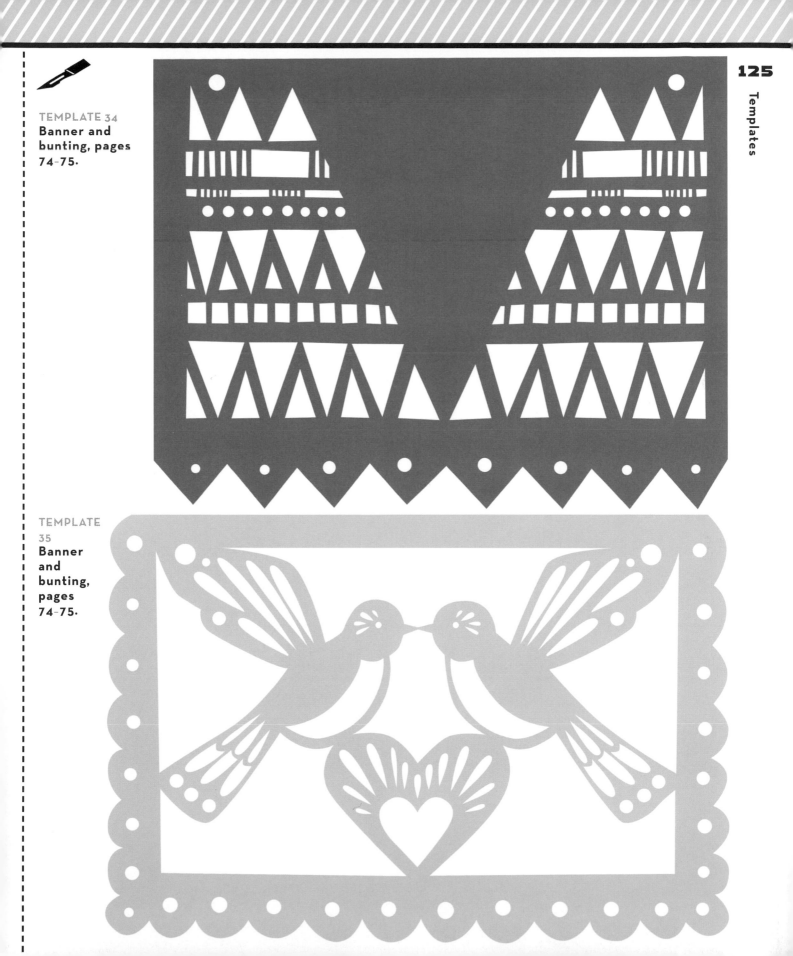

TEMPLATE 34
Banner and bunting, pages 74–75.

TEMPLATE 35
Banner and bunting, pages 74–75.

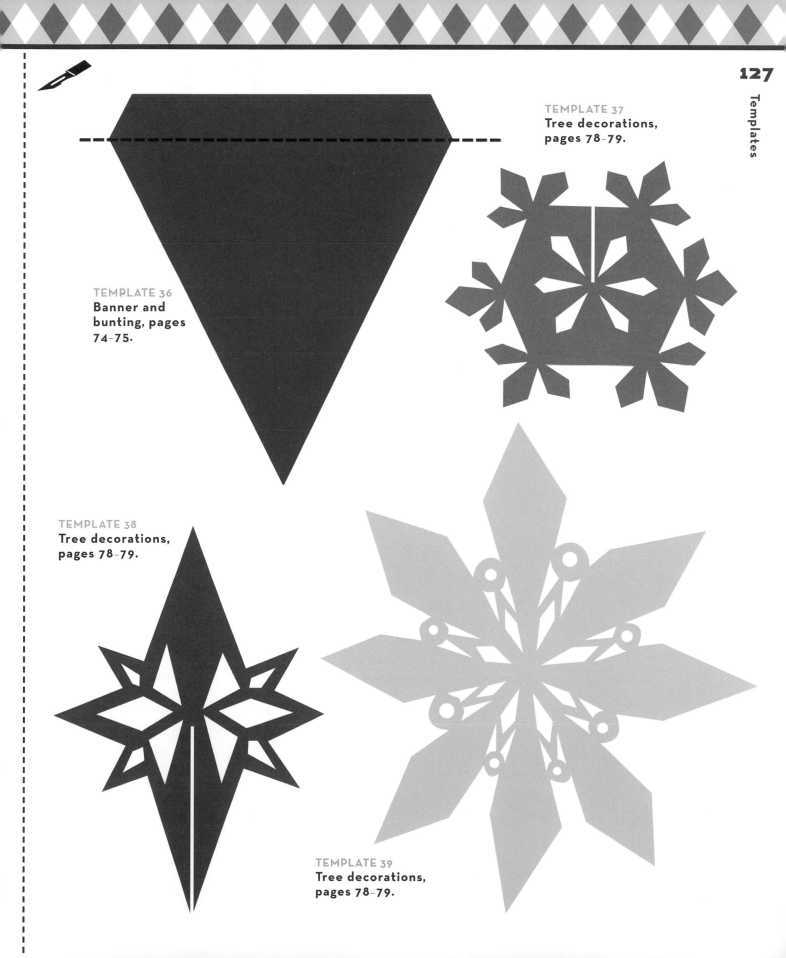

TEMPLATE 37
**Tree decorations,
pages 78–79.**

TEMPLATE 36
**Banner and
bunting, pages
74–75.**

TEMPLATE 38
**Tree decorations,
pages 78–79.**

TEMPLATE 39
**Tree decorations,
pages 78–79.**

FOLD OUT
THE FLAP

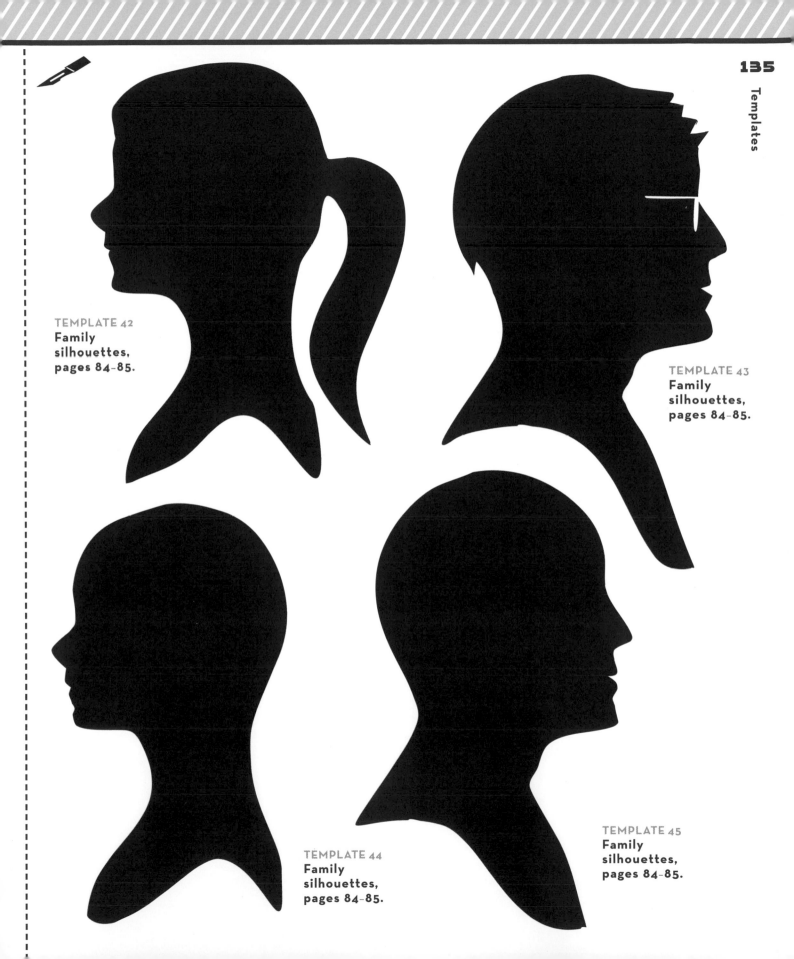

TEMPLATE 42
Family silhouettes, pages 84–85.

TEMPLATE 43
Family silhouettes, pages 84–85.

TEMPLATE 44
Family silhouettes, pages 84–85.

TEMPLATE 45
Family silhouettes, pages 84–85.

TEMPLATE 46
**Frame,
pages 86–87.**

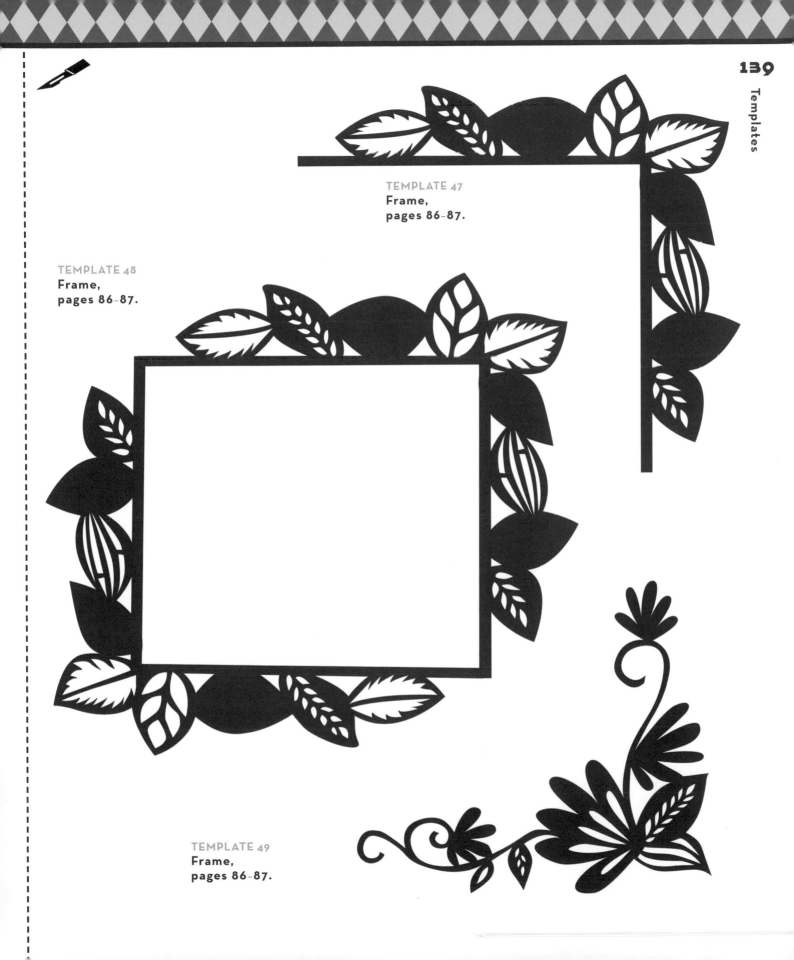

TEMPLATE 47
**Frame,
pages 86–87.**

TEMPLATE 48
**Frame,
pages 86–87.**

TEMPLATE 49
**Frame,
pages 86–87.**

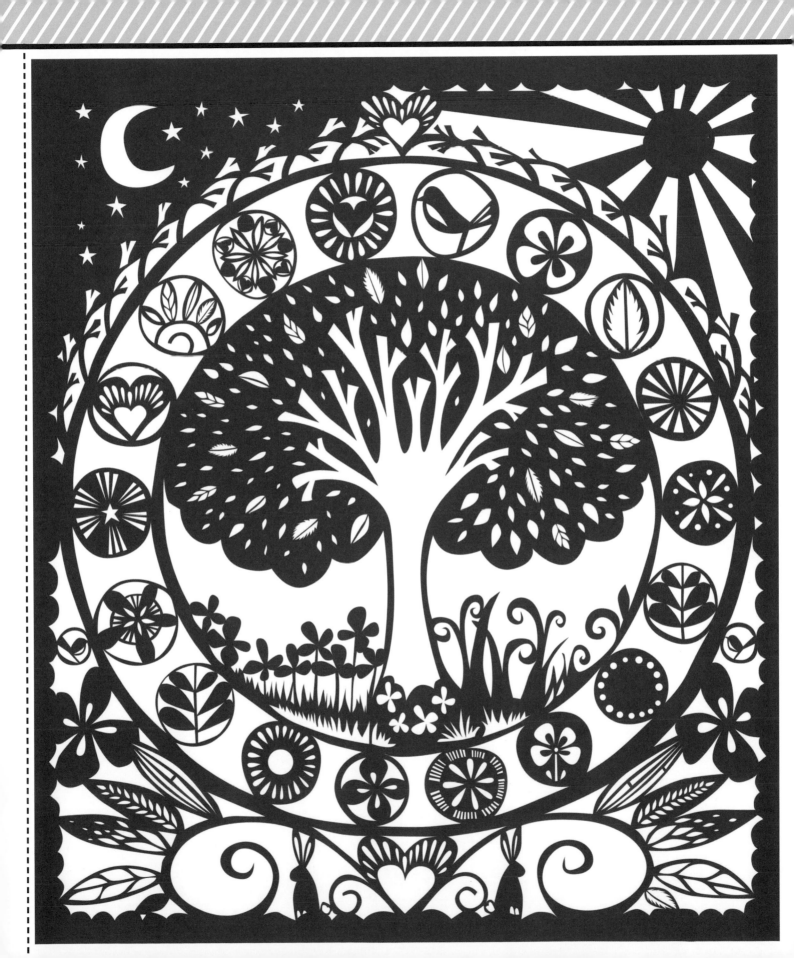